Colorado Close-up

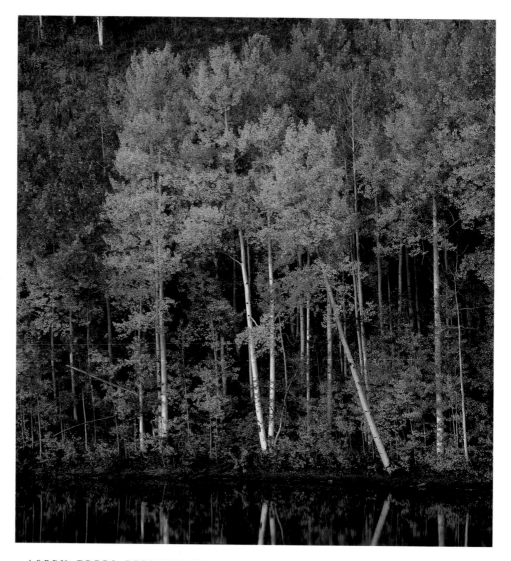

ASPEN TREES REFLECTING ON CUSHMAN LAKE, NEAR TELLURIDE

COLORADO CLOSE-UP

Foreword by Page Stegner

PHOTOGRAPHS BY J.C. LEACOCK

TEXT BY CONGER BEASLEY JR.

FULCRUM PUBLISHING GOLDEN, COLORADO

This book is dedicated to my father, Philip Leacock (1917–1990),
an inspiration to all he touched.

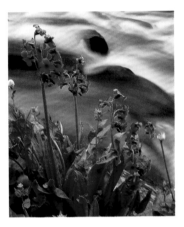

Library of Congress Cataloging-in-Publication Data

Leacock, J. C.
 Colorado close-up / photographs by J.C. Leacock ; text by Conger Beasley, Jr.
 p. cm.
 Includes bibliographical references.
 ISBN 1-55591-325-3
 1. Colorado—Pictorial works. 2. Natural history—Colorado—Pictorial works. I. Beasley, Conger. II. Title.
F777.L43 1997 96-47460
978.8'0022'2—dc21 CIP

Printed in Korea

0 9 8 7 6 5 4 3 2 1

Fulcrum Publishing
350 Indiana Street, Suite 350
Golden, Colorado 80401-5093
(800) 992-2908 • (303) 277-1623

Contents

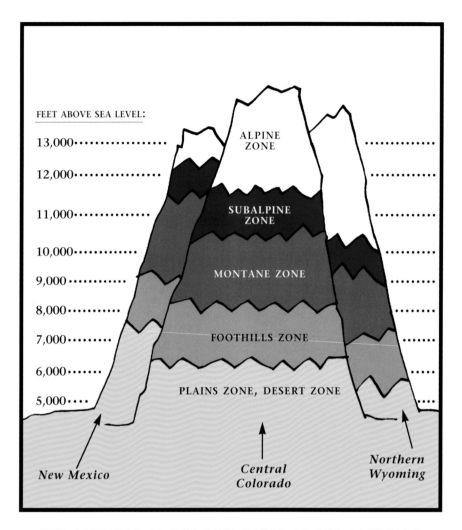

FEET ABOVE SEA LEVEL:

13,000 · · · · · · · · · · · · · · · · · · · · · · · · · · · · ·

ALPINE
ZONE

12,000 · · · · · · · · · · · · · · · · · · · · · · · · · · · · · ·

11,000 · · · · · · · · · · · · · · · SUBALPINE · · · · · · · · · · · · ·
 ZONE

10,000 · · · · · · · · · · · · · · · · · · · · · · · · · · · · ·

9,000 · · · · · · · · · · · · · · MONTANE ZONE · · · · · · · · · · · · ·

8,000 · · · · · · · · · · · · · · · · · · · · · · · · · · · · ·

7,000 · · · · · · · · · FOOTHILLS ZONE · · · · · · · · · · ·

6,000 · · · · · · · · · · · ·

PLAINS ZONE, DESERT ZONE

5,000 · · · · · · · ·

New Mexico

*Central
Colorado*

*Northern
Wyoming*

THE ALTITUDE OF THE LIFE ZONES IN THE SOUTHERN
ROCKIES IS HIGHER THAN IN THE NORTHERN ROCKIES.

Foreword

Ed Abbey once wrote that he personally discovered the town of Telluride during a picnic expedition into the San Juan Mountains in 1957. There is no truth to this. I discovered the town of Telluride a year earlier in 1956 when I was taking respite from tedious classes at the University of Colorado by climbing rock piles in the vicinity of Silverton and Ouray—as far from Boulder as I could reasonably get.

Had I bought Telluride at the time (for the $5,000 I could have paid for it), I would now be a wealthy, if somewhat depressed, old man. Like much of the boom and bust West, my little ghost-town mining community was shortly "discovered" and immediately consumed by CalTex janissaries of trade and commerce. Habitat destruction on a grand scale quickly did in Telluride, just as it did in the Front Range from Fort Collins to Colorado Springs, just as it did in large chunks of Grand, Pitkin, Park and Gunnison Counties.

During a ten-year period from 1982 to 1992, over half a million acres of Colorado's privately owned unreal estate was converted to low-density suburban sprawl, and, indeed, all over the West little (and not so little) developments continue to pop up on what was once agricultural land, uninhabited country, open range. Many of what were historically small, working-class towns exploded as they became transformed into service communities for expensive, wealthy neighborhoods like Vail, Aspen, Sun Valley and Jackson Hole. Public lands were (and are) subjected to an enormous increase in industrial-strength tourism, as well as an increase in use/abuse by the expanding local population.

The second conquest of the West has been well underway for more than two decades, and much too much of its wilderness character has been permanently altered by the wrong kinds of human intrusion. Much ... but not all, as J.C. Leacock and Conger Beasley Jr. clearly demonstrate in *Colorado Close-up*. There are still places where the impact of civilization appears minimal, ecosystems still function, water flows

unimpeded and humans feel supremely insignificant in the midst of a detached and unaware universe.

Colorado Close-up is both a celebration and a warning. In its pictures and its text it implicitly reminds us that our primary response to a beautiful landscape must not be "Wow, what a view, what a great place to have a house," but rather "Wow, what a great place to leave untouched"—as in absolutely untouched. Unless we can make the simple leap from knowing what attracts us to knowing *why* it attracts us, and unless we can act upon that understanding by resisting the impulse to appropriate, to improve upon by paving over, what remains of our wild country, then *Colorado Close-up* will not be a celebration but a memorial. And the West has enough memorials.

PAGE STEGNER

ASPEN LEAVES ON LOG, SAN JUAN MOUNTAINS, UNCOMPAHGRE NATIONAL FOREST

Introduction

Taking a walk in the wilderness can be an exercise in awareness. Beauty can easily be found in a sweeping vista, but it also can be found in the patterns in a rock, the exquisite arrangement of fallen leaves in autumn, a beautiful flower or a graceful water-fall. The more you slow down, look more closely and consciously, the more beauty you will find and the more enriching and rewarding your experience will be. The essence of wilderness is only in small part the vista seen from a national park viewpoint or a mountain summit; wilderness is also the sum of its details, the smaller intricate work-ings of an ecosystem.

That is what this book is about: taking a closer look at this beautiful state of Colorado, already well-known for its stunning mountain views, and exploring the intrinsic beauty and diversity of its more intimate features in each elevation zone: plains, foothills, montane, subalpine, alpine and desert.

Making the photographs for this book was an intensely personal experience. Finding an appropriate viewpoint, setting up the tripod and waiting for the light can be rewarding and emotionally satisfying, but nothing compares with the artistic satisfac-tion of finding in nature the beauty and poetry of an intimate subject and composition that is undeniably your own. This is truly when "seeing" becomes an art and nature an extension of your being. Not only do you become close to your art but to the natural world in all of its intricacy.

A close look at Colorado's ecosystems clearly indicates that they are in a state of "dis-ease." From the eastern plains, through the foothills and mountains, to the western deserts, Colorado is experiencing an unprecedented amount of environmental abuse and habitat destruction as a result of population increase. It is my hope that in some small way this book might encourage people to look more closely not only at the beau-ty of Colorado but also at the delicate ecosystems within which that beauty resides.

J.C. LEACOCK, NEDERLAND, COLORADO

PLAINS GRASSES,
BOULDER COUNTY OPEN SPACE

I
Plains

One-third of Colorado—the legendary mountain state—consists of rolling plains. For five hundred million years, until roughly seventy million years ago, the interior of the North American continent was submerged under a succession of shallow seas. "A thousand miles of chest-deep reef," says Gary Snyder, "sea bottom riffled, wave-swirled, turned and tilled by squiggly slime swimmers … ." Sedimentary deposits, some as thick as 10,000 feet, stacked up on the seabed floor.

Around seventy million years ago, the continent began to rise. The seas subsided; mountains rumbled up in the west, tumbling debris down onto the seabed floor. Steady winds blanketed the area with additional layers of dust and volcanic fallout. In a span of sixty million years, the old seabed was transformed into an east-sloping plain, crowned with isolated mountain ranges.

Additional uplift caused the streams and rivers cascading out of the mountains to cut down through the sedimentary layers, carving high divides and broad plateaus, roughing out the landscape of the Great Plains. Within the last two million years, the South Platte and Arkansas Rivers, flowing northeast and southeast respectively, accompanied by abrasive winds, sculpted the features we know today as the Colorado flatlands.

Comanche National Grassland in southeast Colorado unfolds to the edge of the horizon like a sheet of construction paper, pressed and smoothed by the weight of a ponderous hand. The fresh spring air is washed with swaths of pastel colors: blue sky, tawny grass, more blue sky and tawny grass. To the west, 60 miles away, loom the twin, snow-patched summits of the Spanish Peaks. *Wah-to-yah* meaning "breasts of the world" in the Ute Indian language. They hover on the horizon like a mirage, delicately balanced on a cushion of shimmering air.

A few miles from Vogel Canyon I brake the car to a halt. The ground sweeping out to either side of the dirt road looks as dry and taut as a deerhide drum. Out of the car, I tramp a generous circle between tufts of spiky yucca and twisted cholla. Between my feet glisten rubbly white secretions of calcium carbonate. Hardpan. The solid alkaline floor of the plains.

The Front Range of the Rocky Mountains casts a long, steady rain shadow over the flatlands. Moisture-laden clouds rolling in from the west drop their loads on the summits, valleys and foothills; by the time those same clouds roll out over the plains, they're pretty well depleted. The amount of moisture that annually falls on eastern Colorado varies from 2 inches to 26. Grasses and forbs (leafy plants) seldom exceed 2 feet in height, which limits their exposure to the wind and sun. The nearly vertical arrangement of grass blades maximizes light absorption in the cooler part of the day,

PURPLE LOCOWEED *(Astralagus mollissimus)*,
ELBERT COUNTY

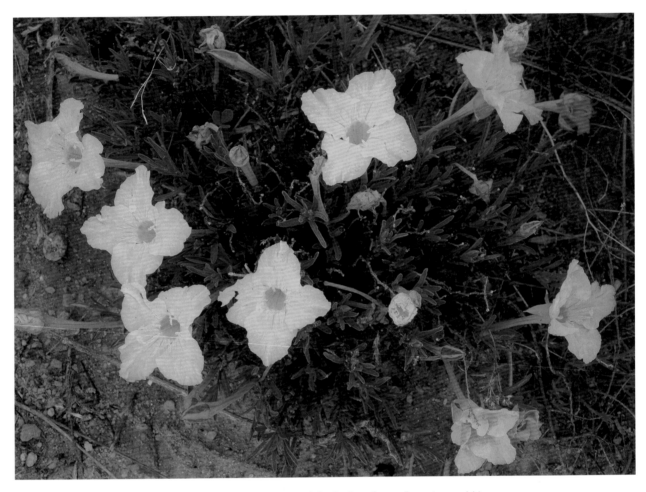

WESTERN PRIMROSE *(Calylophus hartwegii),*
PAWNEE NATIONAL GRASSLAND

while minimizing high-noon radiation. The majority of the biomass is located in the root system, enabling plants to regenerate quickly after being cropped or burned.

Streams and rivers, issuing from the distant Rockies, provide the primary source of water; after tumbling through the foothills, they slow to a trickle or disappear altogether on the blotterlike crust of the plains. Despite its dryness, the ground is potentially productive. The scant flow of moisture allows nutrients to remain locked in the soil rather than leached out; when properly irrigated, the soil can produce generous yields of wheat, soybeans and corn.

Vogel Canyon has been gouged out of the friable earth by a tributary of the Purgatoire River. The canyon falls away from the grassy flats, down through a generous split bounded by sandstone cliffs. At the bottom the tributary cuts a stringy gash along the parched floor; the trunks and limbs of twisted cottonwoods sprawl in the grass like fossilized bones. Next to one of these desiccated limbs, I espy a delicate prairie wallflower, a member of the mustard family—four bright yellow petals, like condensations of April sunlight, patterned in the shape of a cross.

Prickly pear cactus grows plentifully down here, as well as cholla and yucca. Tough, hardy, durable, the yucca or Spanish bayonet flourishes throughout the Colorado grasslands. Spiky and sharp, the iridescent green blades bristle in the dry wind like porcupine quills.

The plant's white flower attracts the female pronuba moth, which punctures the ovary of the blossom and deposits its eggs inside. Pollen from other yucca plants dusting the moth's body fertilize the flower. The flower thus functions as a germinator for the plant and an incubator for the moth larvae. Yucca and moth. As delicate a symbiotic pairing as you're likely to find in the natural world.

Wandering along a dusty trail through the depths of the canyon, I see a lark bunting (the Colorado state bird). Sliding on the cusp of the April wind comes the cheery whistle of a western meadowlark. At least 275 species of birds either live in or migrate through flatland Colorado. Observable in spring on the national grasslands are the lesser prairie chickens, with their elaborate courtship rituals: a bobbing, dipping motion Plains Indians imitate in their dances.

The country is a mecca for rattlesnakes. Heat, trapped between the sandstone walls, thickens as the day proceeds, stirring the sluggish reptiles. Prairie rattlers and massasaugas, both deadly poisonous, thrive on the rocky hillsides and canyons. Blotchy, with a thick tail, the massasauga ranges from the southwestern grasslands all the way to southern Ontario. The name is Chippewa for "great river mouth." Fortunately it's a bit early in the season for snakes to be out in force; nonetheless, I feel them watching me from their burrows and holes.

The emptiness of the country is deceptive. The twin masses of sky and land, divided by the faintest of horizons, suggest a balanced cosmology: the material world juxtaposed in soothing equipoise with the spiritual; earth and sky abutting one another in harmonious counterpoint, each sphere subtly reflecting the immensity of the other. No wonder early inhabitants were inspired to peck and paint their impressions of what they felt and saw on the rusty walls of these remote canyons. Southeast Colorado is rich in petroglyphs and pictographs, some representative, others arcane and indecipherable. Graffiti besmirches many of these sites—pecked, scratched, carved and spray-painted by Kilroys of our own era.

Cattle trails lace the canyon floor; everywhere I see the crusty, wrinkled wafers of their droppings. The abundance of yucca and cholla, the paucity of decent grass, are obvious signs of overgrazing. Before the farmers and ranchers, the Colorado grasslands

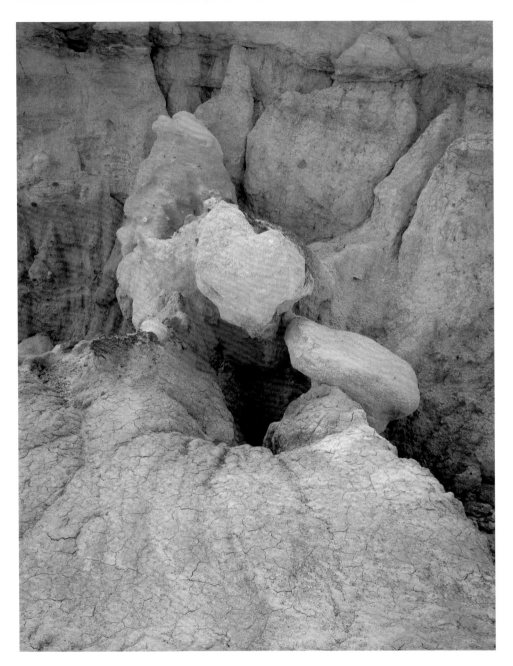

PAINT MINES BADLANDS FORMATIONS,
EL PASO COUNTY

were dominated by a mix of blue grama and buffalo grass. These shortgrasses had long fibrous root systems, adapted to withstand drought, the heavy hooves and hungry teeth of roving buffalo. Today, natural succession is persistently stifled by hordes of stationary cattle, which crop the taller grasses, thus contributing to the increase of weedy drought-resistant species such as cholla, cacti and yucca.

In 1820 Major Stephen Long led an expedition across the Great Plains that was to fix the image of the region in a negative light. The survey's official chronicler deemed it "a dreary plain, wholly unfit for cultivation … uninhabitable by a people depending upon agriculture for their subsistence." Subsequent maps designated the area as the "Great American Desert."

Before the Civil War, settlers and prospectors hurried across the region to the gold mines of the Rocky Mountains and the green valleys of the Pacific Coast. Serious settlement did not begin until after 1862 when the Homestead Act made millions of acres available to land-hungry immigrants. The grasslands ecosystem underwent a radical alteration. Railroad tracks linked the region to worldwide markets; nomadic Indians were herded onto reservations; buffalo were systematically annihilated. (For the record, the last four wild bison in Colorado were killed in 1897 in an isolated valley in the northeast corner of South Park.)

By the 1880s cattle had replaced buffalo as the reigning ungulates. Outfits such as the Prairie Cattle Company (a Scottish corporation) controlled millions of acres of rangeland stretching from the Texas Panhandle to southeast Colorado, on which hundreds of thousands of cattle freely grazed. While it is certainly true that buffalo herds laid waste to everything in their path, invariably they moved on, leaving the root systems intact, permitting plants and grasses to recover. Cattle grazing in the same area year after year kept the grass shorn and the ground trampled, especially around

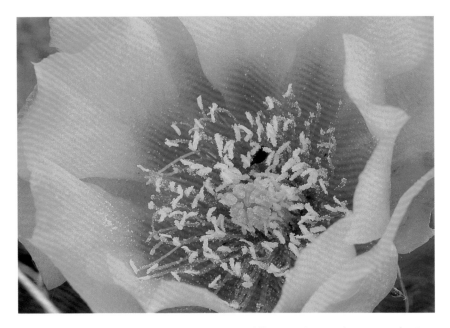

PLAINS PRICKLY PEAR FLOWER *(Opuntia polyacantha)*,
WELD COUNTY

creekbeds and waterholes. Homesteaders with their steel-tipped plows flayed the fragile topsoil off the surface. The cumulative effect was devastating. What had once been a circular immensity of cosmic proportions was reduced in a matter of a few decades to a tight, interlocking grid of contiguous plots.

Before the plow broke the plains in the nineteenth century, native grasses intercepted the rain and retarded the impact of the wind. The removal of the protective cover exposed the soil to the worst effects of erosion. This took several decades, but by the time the Great Depression rolled around, the region was primed for disaster. Black Sunday, April 14, 1931, marked the first of the devastating dust storms that stripped not only Colorado, but nearly all of the Great Plains, of precious topsoil. Clouds billowed into the stratosphere, darkening the air over cities along the Atlantic seaboard. Oil, gas and aquifer extractions completed the destruction. No North American biome has been as ruthlessly savaged as the Great Plains.

Despite these outrages, the mystique remains. The space, the soaring sky, the immeasurable distances. Not long ago, Comanche and Kiowa warriors fasted and prayed on whatever elevations they could find, crying out for a vision, an image, a totem, that might sustain and guide them through the course of their perilous lives. If the inhabitants of the little towns along the Arkansas River today seem a bit tight-lipped and reticent, maybe they're just working hard not to be swept away by the mythical dimensions of this strange lonely land.

In every way eastern Colorado fosters a climate of excess. Weather, behavior, agriculture, animals. What do you expect from a landscape where the summer heat congeals on the horizon in tantilizing mirages? Where the rivers vanish for miles, only to reappear with a sluggish purl, before sinking out of sight again. A trickster landscape, chimerical and illusory, conjured by Coyote, whose manic laughter can always be heard

just under the edge of the wind. That same wind, incessant and maddening, that dries out everything at seven times the rate of precipitation that falls annually. No wonder things age with such vehemence, such as the gnarled and twisted cottonwoods I saw down in Vogel Canyon. Corporeal desiccation is the inevitable apotheosis of all living things. As the body withers, the spirit fidgets and stirs.

Late that afternoon, driving away from Vogel Canyon, I saw a herd of pronghorn antelope. Native to these parts, they were nearly eliminated by hunters and pioneers. In recent years they have made a dramatic comeback. Of all the North American ungulates, they are the most graceful. As the car eased over a rise, they burst across the road then slowed a few yards into the grass on the other side. I stopped the car and rolled down the window. They looked at me, I looked at them, feeling a special thrill in the steady gaze of their liquid eyes. The white splotches on their bellies and rumps gleamed with snowy brightness in the fading sun.

The pronghorn is the fastest animal in the Western Hemisphere, one of the fastest in the world; it has been clocked at speeds in short bursts of 70 miles per hour. Thirty miles per hour is an easy cruising speed for this gracile creature, which it can maintain for up to 15 miles, running with its mouth open, not from exhaustion, but to take in extra oxygen. The animals continued looking at me with an ingenuous curiosity that made me almost avert my own eyes. Then, as if on cue, with balletic precision, they turned and walked with stately measured steps over the grass and down into a tree-lined draw.

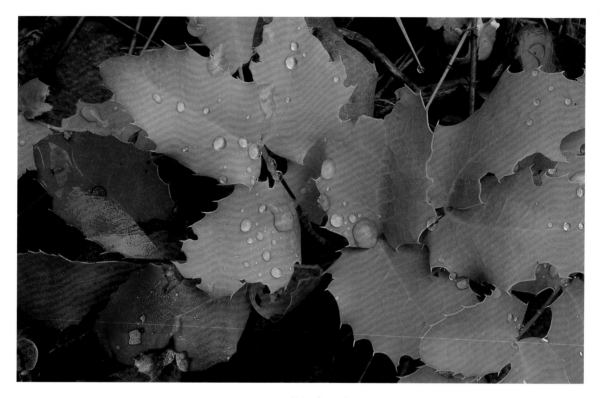

OREGON GRAPE *(Mahonia repens),*
ELDORADO STATE PARK

II
Foothills

Foothills. Piedmont. Uplands. The zone goes by different names. In Colorado, foothills is the more popular term. Lumpy, rolling, undulant terrain, bunching into scrub- and tree-dotted hills, huddled at the base of the verdurous slopes of the Front Range. Latticed with creeks, lush with grassy meadows, shrubbed with stands of Gambel oak and mountain mahogany. A mix of montane and plains/desert species, the zone is fringed on the high side (8,000 feet) with ponderosa pine and Douglas fir; on the low side (6,000 feet) with piñon-juniper, yucca, rabbitbrush and Great Plains grasses. Deciduous species flourish in the riparian corridors: narrowleaf cottonwood, box elder, green ash and wild rose.

Foothills. Fulcrum between the soothing flatness of the plains and the daunting verticality of the mountains. The place where the land, like waves approaching a breakwater, crumples into a welter of lumps and folds. From this point the upward climb to the Rockies begins. From here to the highest "fourteener" the operative word is ascent.

I'm hunkered down in a thicket of Gambel oak in the Garden of the Gods in the heart of the Colorado foothills. Doubled up, knees against my chest, peering out through a tangle of wiry branches, like a kid in a closet with the door half-closed. The time is mid-spring. Dry leaves, diminutive, with the serrated oak outline, cling to the twigs and stems. Tiny buds have formed at the tips; in a few days, barring the onslaught of a late winter storm, they will blossom into green leaf.

There are times when the landscape calls for full immersion. Maybe it was the magpie waddling across a litter of dead leaves deep inside the thicket. Maybe it was the scrub jay, basking in the sun at the tip of a swaying limb. Maybe it was the deer tracks, intagliated in red mud, circling the perimeter. Whatever, I felt an overpowering urge to enter that world—not just as an observer, but something more. On all fours, sweating and grunting, I wiggled through a narrow opening to the center of the thicket, where I'm huddled now, giggling, huffing for breath.

Gambel oaks—sun loving, rooted in coarse-grained soils, reaching heights of 8 to 12 feet—form the dominant foothills shrub. The acorns are small, less than an inch in diameter, a perfect browse for mule deer. In the fall the leaves wither in a bold display of pigments—red, yellow, orange. What must it be like, I think, to sleep inside this thicket on a crisp October night, exposed yet protected, enveloped in a riot of color?

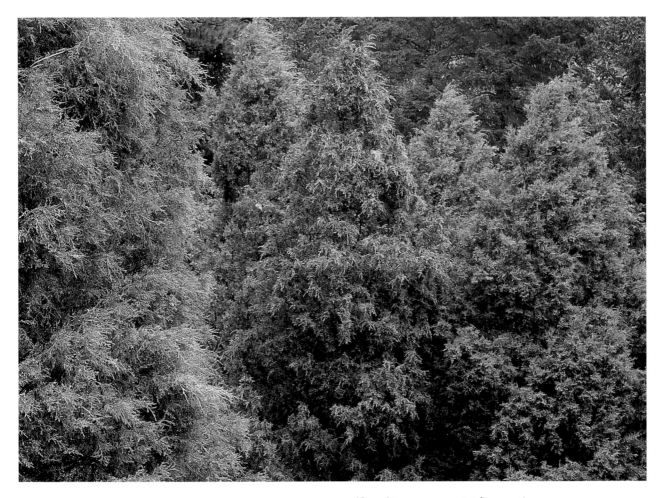

COLORADO JUNIPER TREES *(Juniperus scopulorum)*,
ELDORADO STATE PARK

Mountain mahogany is another predominant foothills shrub. It grows on dry rocky slopes, normally 6 to 10 feet high. The leaves, borne on little spurlike branches, resemble those of a birch tree. Medicinally it has many uses: as a laxative, as a salve, as means of repelling bedbugs (when placed under a mattress).

We can learn a lot about mountains by examining the foundations on which they rest. Foothills offer clues as to how they were formed. Around 350 million years ago the ancestral Rockies towered over much of Colorado. The easternmost chain of these peaks, known as *Frontrangia,* was located some 30 to 50 miles west of the present-day Front Range. A pause in the uplift, accompanied by relentless erosion, wore down the peaks, spreading rubble eastward in enormous alluvial fans.

Around sixty million years ago, the modern Rocky Mountains began to thrust upward through the eroded layers of the ancestral range. No one knows exactly why this orogenic upheaval occurred. The cause lies within the complex relationship of crustal plates girdling the globe, but the actual mechanisms have yet to be defined by geophysicists. The granite core of the present-day Rocky Mountains arose with remarkable swiftness, tilting the overlying strata almost perpendicular to their original positions. In time, wind and water dissolved the less resistant rock, leaving the bladelike formations we see today all along the Front Range. Bare rocks, thin rocks, smooth rocks, bland and brightly colored, weathered into anthropomorphic shapes resembling osculating camels and slumbering dinosaurs, which weekend climbers, in places such as the Garden of the Gods, attempt to scale with ropes and pitons.

So goes our version of the story. Ute Indians, who first came to Colorado around seven hundred years ago, have their own. In the beginning there was no earth, only blue sky, sunshine, clouds and rain. Manitou lived by himself high up in the sky. He was lonely, so one day he bored a hole through the floor of the sky so he could look

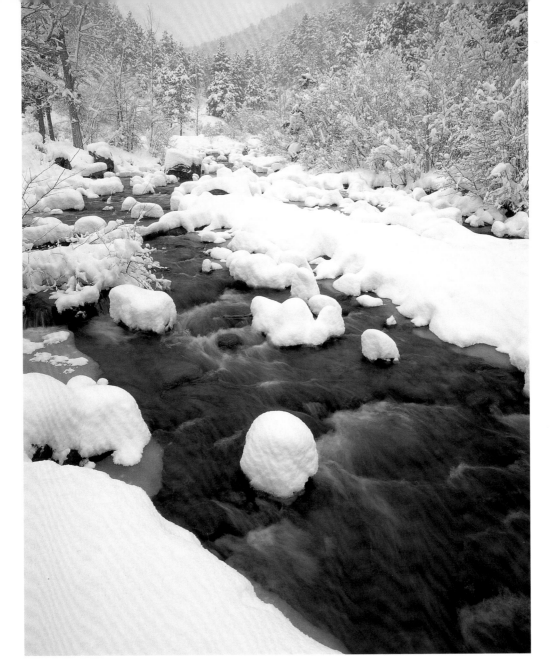

LEFT-HAND CREEK AFTER SNOWSTORM,
ROOSEVELT NATIONAL FOREST

down at the nothingness below. Through this hole he poured rain and snow; through it he also poured all the dirt and stones he could find on the floor of the sky. The debris stacked up to form a chain of mountains. One day Manitou slipped down through the hole to inspect his handiwork. The mountains were big enough, but they were cold and featureless, bare dirt and rock. "I need to make them more interesting," he thought. So he stooped and touched the earth, and wherever he did, trees and flowers appeared. Sunshine beaming through the hole in the sky melted the snow and ice, creating rivers and lakes. Water ran down the mountainsides, grass sprang up, seas pooled far out on the horizon—overnight the world became more beautiful and complex. But that wasn't enough; Manitou still felt lonely. So he created animals, birds and insects. He created a people called the Ute. Then he was happy. Every day he stepped down through the hole in the sky and wandered around the fields and forests, listening to the wind, smelling the grass and pine needles.

The Garden of the Gods was a holy site for the Ute. Many clans and families wintered there. Water and timber were plentiful, as were edible plants and small game; antelope and buffalo roamed the nearby grasslands. From this spot the famous Ute Trail wound up through Manitou Springs (with its healing waters) to the green forests and lofty pastures of the highlands. The remarkable bladelike formations possessed special power; old people, knowing their time was near, climbed into the rocks and wedged themselves in the crevices, singing their death songs in the light of the fading sun.

On all fours, my nose snuffing through sun-drenched litter, I crawl backwards out of the thicket and continue along the trail. A mixed stand of piñon and juniper catches my attention. The piñon-juniper system forms a kind of pygmy forest, wide spaced and tenacious. Both trees send down deep roots. The one-seed juniper, a hardier species, acts as a nursery tree for the piñon, providing shade, protection, enabling the piñon to take root and grow.

AUTUMN LEAVES ON SURFACE OF POND NEAR BOULDER CREEK,
BOULDER CANYON

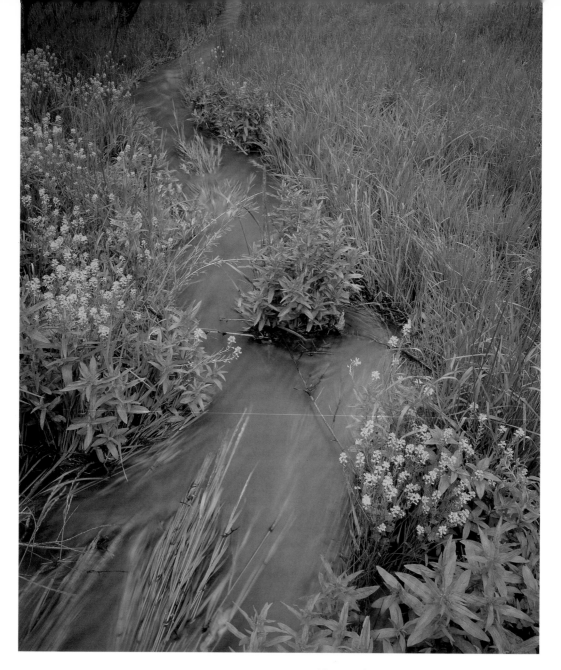

SMALL STREAM WITH FIELD MUSTARD *(Brassica rapa)* IN BLOOM,
LEFT-HAND CANYON, BOULDER COUNTY

Piñon nuts are highly nutritious. The Utes pounded them into cakes and carried them out on the plains when they hunted buffalo. The sticky pitch had many medicinal uses: as an expectorant to relieve lung congestion, as a salve for splinters and cuts, as a urinary tract disinfectant.

In addition to the scraggly one-seed juniper, the Rocky Mountain juniper—symmetrical, dark green and shapely—is also found in the foothills. The Ute still use the aromatic properties of both trees to ward off pernicious influences. Tossed on hot rocks inside a sweat lodge, the needles and berries give off a salubrious odor that helps restore the balance of mind and body indispensable to longevity and good health.

At various points along the trail, threading the slopes around the Garden of the Gods, I take in the sight of the plains swooping eastward hundreds of miles, down the long tilting grassy tableland, all the way in my mind's eye to the Missouri River Valley and the Ozark Plateau. Pivoting on my heels, I contemplate the massive uplift to the west: cliff, slab, crag, crest; a lofty, jagged line rising all the way to the granite crown of Pikes Peak, looking, in Frank Waters's phrase, "like the bald head of an old gentleman cautiously poking out from his winter covers."

The first (recorded) person to scale that bald head was Edwin James, chronicler of the famous Stephen Long expedition, which explored the Front Range of Colorado from the Poudre River to the Arkansas. The date was July 14, 1820—a banner day in the history of botanical collections, with James describing and naming some twenty new plants. Near Palmer Lake in the foothills, James identified the blue columbine, later to become the Colorado state flower. Each year in Burlington, Iowa, where he died in obscurity in 1861, blue columbines bloom on his grave.

I stroll around the perimeter of a grassy meadow, bounded by rust-colored blades on one side and a sage-dotted ridge of Niobrara sandstone on the other. In the grass

edging the trail, I spot Indian paintbrush and yellow cinquefoil, obvious indicators of the onset of spring. Lithe grasses shimmy over the surface of the wide meadow—blue grama, western wheatgrass, little bluestem. A trio of cottonwoods rises from a moist depression, their gnarly branches tipped with silver-green buds.

From atop a grassy hill at the south end of the Garden of the Gods, I can see downtown Colorado Springs and the mouth of Ute Pass. Every summer in the early 1920s my grandparents journeyed out to Colorado Springs from Missouri with my mother and her younger brother, a darling boy named Billie, who suffered from asthma. The boy was fair, pale, with soft blond hair and luminous blue eyes. To relieve his congested breathing, my grandmother gave him hypos; at night when he gasped for air, she held him in her lap and rocked him to sleep, crooning lullabys in a gentle voice. In four leather-covered journals dating from 1921 to mid-1924 she recorded in a steady copperplate script the tribulations that Billie endured. There was something saintly about the boy—quiet, taciturn, well-mannered; he suffered miserably, but never complained.

The salubrious climate of Colorado Springs was thought to work miracles for asthmatics. My grandfather was a successful businessman, and the family spent the days doing what they could to make Billie comfortable. Picnics, parades, tea dances, band concerts in Palmer Park, long drives through the Garden of the Gods, with Billie, looking ethereal and angelic, dressed in a blue and white sailor suit, clutching his baseball glove, sitting up front with the chauffeur. I'll never forget the expression of pain that darkened my mother's face whenever she mentioned his name. In 1924, at age seven, on a gloomy afternoon in May, with thunderclouds piling up over the Missouri River, Billie passed away.

A marsh hawk suddenly appears, dispelling my reverie, swooping and gliding, identifiable by the white patch on its rump. Unlike other raptors, marsh hawks don't hover

over their prey; they follow the contours of the terrain, riding the wind, sliding over the slopes, flaring their wings, gusting up, sailing down, searching the grass with their beady pointillist eyes. I stand still. The aerodynamics of the bird are a marvel to behold: the sway, the balance, the buoyancy; the way it utilizes each vagary of the wind, stroking out a kind of fluid calligraphy that vanishes the instant it appears.

At one point the bird passes directly over my head, locking eyes momentarily with mine. A thrill ripples through my chest. There is no hint of recognition here; it doesn't nod or blink. The eyes remain opaque and wild, beyond my capacity to fathom. The sight of it takes me out of myself, the sorrow still lingering in these hills. Maybe I'll dream about it tonight.

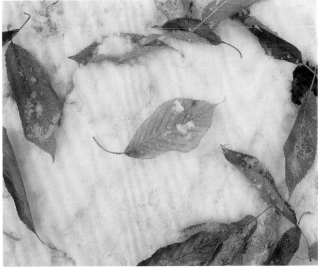

ROCKY MOUNTAIN ALDER
(*Alnus Incana ssp. tenuifolia*) LEAVES ON SNOW,
BOULDER CANYON

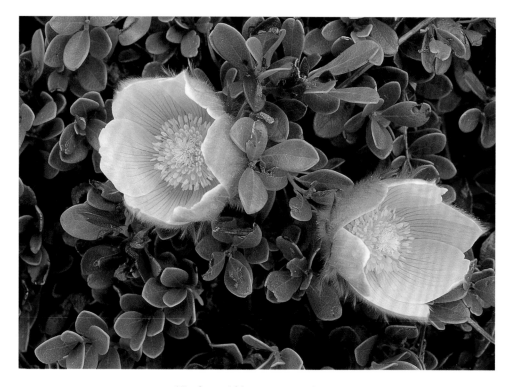

PASQUEFLOWERS *(Pulsatilla patens)* GROWING AMONGST
KINNIKINNICK *(Arctostaphylos uva-ursi)*,
ROOSEVELT NATIONAL FOREST

III
Montane

Rocky Mountain weather is volatile and unpredictable. Lacking the moderating influence of an ocean or other large body of water, the weather can shift from warm and sunny to cold and stormy, back to warm and sunny, in less than an hour.

Local climates within the mountains vary enormously, depending on elevation, site direction and site orientation (slope, valley or ridgetop). On average, air temperature decreases about 3.5 degrees Fahrenheit with each thousand-foot elevation gain.

Masses of moving air rise as they encounter mountains, forming convective clouds that release huge amounts of rain or snow. In the spring and fall, humid air from the Gulf of Mexico pushes against the east slope of the Front Range, creating "upslope" storms that leave the west side virtually untouched. Summer weather in the Rockies follows a fairly consistent pattern: sunny mornings, stormy afternoons, clear nights.

Wind is a prominent feature in the Colorado Rockies. At the higher elevations, unimpeded by trees, it rips over the summits and ridgelines, sweeping snow off the alpine tundra. Valley winds occur when the air, warmed by the afternoon sun, rises gently upslope, only to sink at night as the temperature cools, blowing back down in the early morning. Chinooks usually occur in late winter or early spring. These dry winds flow down the east slopes of the Front Range, attaining speeds of over 100 miles an hour.

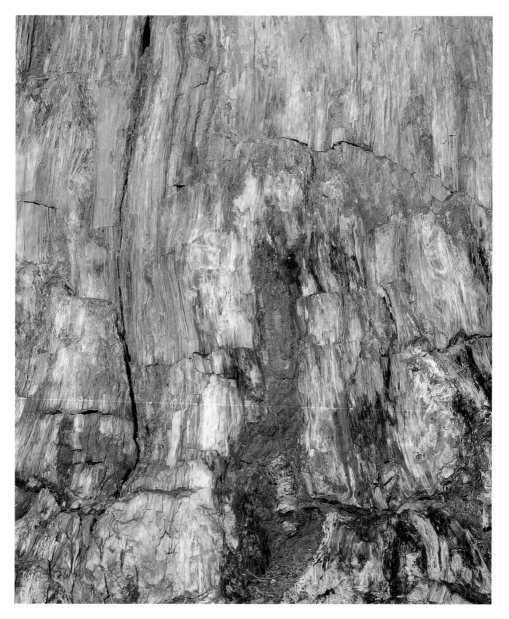

DETAIL OF FOSSILIZED SEQUOIA REDWOOD STUMP,
FLORISSANT FOSSIL BEDS NATIONAL MONUMENT

Strolling along the Sawmill Trail in the heart of Florissant Fossil Beds National Monument, I spot a tiny violet-tinged bud protruding from the grass. I get down on my hands and knees to examine it. The smooth, tightly bunched, light-purple petals are covered with fine sticky hairs; droplets of crystalized ice cling to the silky folds. Snowflakes twirl from a gloomy sky; the air is laced with a lingering chill. Curiously, the shattered fragments of reddish granite on which I kneel feel tantilizingly warm.

It's late April in the Colorado montane (elevation 8,400 feet). Swiveling my head, I have a clear view to the east of the icy alpine slopes of Pikes Peak. Turning in the opposite direction, I see, within the span of my reach, plump and defiant, pronging up to a height of 2 inches, the bold, curvaceous bulb of the pasqueflower. The "Easter" flower; the first mountain wildflower to blossom in spring.

The forests of the montane are diverse, composed of mixed stands of ponderosa, Douglas fir, lodgepole and aspen. The ponderosa is the most familiar tree in the Rocky Mountain west. Tall, with long needles, a broad open crown, scaly yellow bark that in hot sunlight gives off a fragrant vanilla smell, the tree extends from the foothills (6,500 feet) to nearly 10,000 feet. It's easy to identify, both by its distinctive bark and clusters of two to three olive-green needles. A long taproot enables the tree to thrive in dry, rocky soils; the root also keeps the tree from toppling over in the seasonal winds that roar through the mountains with hurricane force.

Mixing with ponderosa on the shadier north-facing slopes is the Douglas fir, smaller cousin to the grandiose Pacific Coast tree of the same name. The Rocky Mountain Douglas fir occupies an ecological niche between semiarid ponderosa sites and cooler, wetter subalpine forests. The deep green foliage and tapered crowns give the fir a distinct Christmas tree appearance. Unlike the cones of true firs which stick up like candles from the topmost branches, Douglas fir cones grow everywhere on the tree. Three-pronged bracts poking between the cone scales resemble tiny mice in the act of disappearing into a hole.

Walking through a grove of lodgepole pines is a bit like walking through a tree farm. Ute Indians favored the trunks as tipi center poles because they grew so uniform and straight. In moister places the normally sparse understory is carpeted with myrtle blueberry, juniper shrubs, kinnikinnick and buffaloberry. Birds call back and forth—white-breasted nuthatches, yellow-rumped warblers, pine siskins, mountain chickadees.

Logging, windfall, disease, landslides, road construction, fire—especially fire—provide fertile ground for the opportunistic lodgepole; the seedlings are especially tolerant of ashy, fire-scorched soils. Forest fires are beneficial forms of renewal. They return minerals to the soil that have accumulated in the growth of wood and set the stage for ecological succession; they also promote greater animal and plant diversity.

Within weeks after a fire, lodgepole seedlings sprout from the ashes. Once they take hold, they climb rapidly toward the sun, away from the shade, crowding out competitors: wild raspberry, wild rose, elderberry, aspen. After the canopy matures, little direct sunlight reaches the forest floor. Natural forest succession usually favors shade-tolerant conifers. Eventually, Douglas fir and Engelmann spruce seedlings creep into mature lodgepole stands, edging out the invader, returning the forest to its climax state.

FACING PAGE: ASPEN COVERED HILLSIDE IN AUTUMN COLOR, MCCLURE PASS, WHITE RIVER NATIONAL FOREST

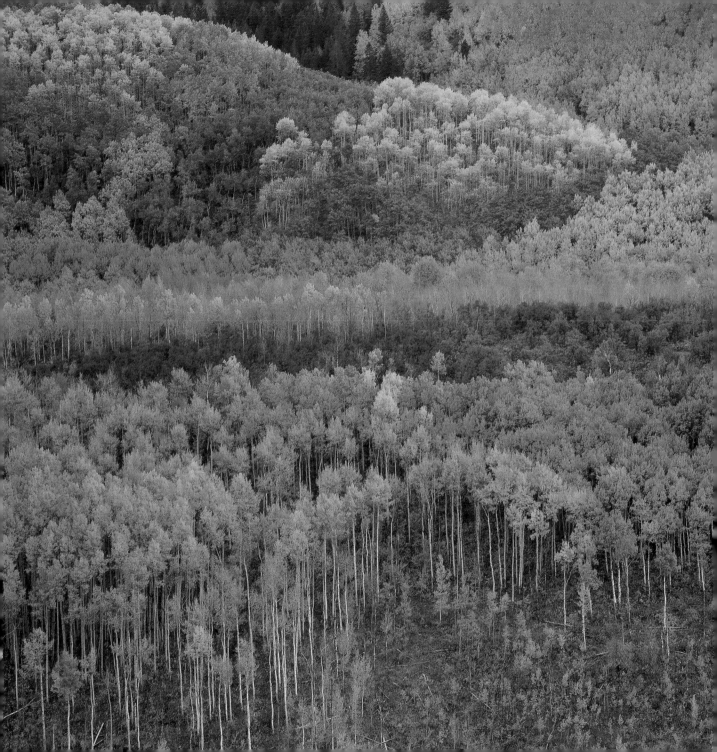

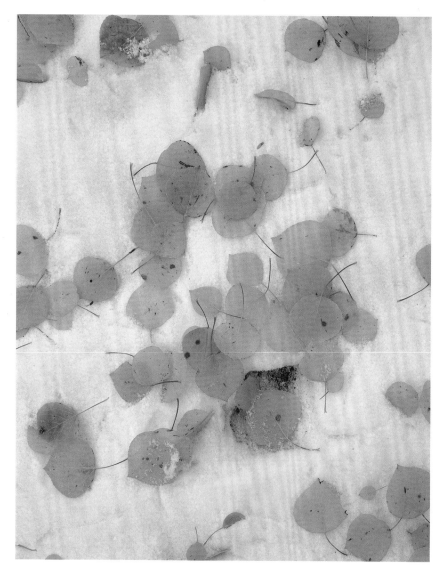

FALLEN ASPEN LEAVES ON SNOW,
ROOSEVELT NATIONAL FOREST

Groves of shimmering aspens are one of the sublime glories of the Colorado autumn. Related to the willow, the famous quaking aspen blankets the slopes of the Rocky and Sangre de Cristo Mountains at elevations between 8,000 and 10,000 feet. Like the lodgepole pine, aspens are pioneers; they colonize sunlit spaces ravaged by fire, avalanches and landslides. The silky hairs covering their tiny seeds send them whirling long distances on the wind.

Aspens occupy deforested areas with amazing rapidity. The initial invasion takes five to ten years; maximum density is usually attained within twenty-five to fifty years. Aspen ecosystems feature a rich herbaceous understory and abundant animal life. Lateral roots radiate out as much as 50 feet from the parent tree. These roots produce new shoots, called suckers. Each sucker can develop into a clonelike replica of the parent.

The bigger the aspens, the more shade they cast. Conifer seedlings such as the Douglas fir, Engelmann spruce and subalpine fir, attracted to the shadowy floor of the aspen grove, take hold and thrive. Eventually the conifers crowd out the aspens; susceptible to infection and diseases, browsed upon by mule deer and elk, infested by woodpeckers and insects, the trees begin to die off. The conifers emerge triumphant, dropping generations of dry needles, turning the understory into a tinderbox. A summer thunderstorm convulses the slope, fire erupts, the slope is reduced to smoking litter and the whole process begins again.

Sometimes lying on the ground provides the best perspective for taking in a particular habitat: on your side, flat on your back, eyes half-lidded, mind emptied of distracting chatter, allowing sounds, smells and sights to percolate through the senses. "Supine traveling," photographer J.C. Leacock calls it. While he sets up the tripod and clamps on the camera and peels the protective wrapper off a fresh roll of film, I lie down some

distance away, stretch out my arms and fall into a semicomatose state. It's not really snoozing; it's more like a form of meditative consciousness. Tranced out, yet alert.

Still sprawled at the side of Sawmill Trail, one finger gently nudging the folded blossoms of the pasqueflower, I feel the earth doing funny things. Stirring, shifting, expanding. Sloughing off its wintry scales. A Stellar's jay squawks from a nearby branch. High overhead, a red-tailed hawk loops in wide circles, the fan of its russet tail gleaming in the vagrant sun.

The manner in which people dream says a lot about who they are. The night before he discovered the fabled Cripple Creek mine, while sleeping outside under a pine tree on the south slope of Battle Mountain, a figure came to W. S. Stratton in a dream and whispered to him that a fabulous quantity of gold lay directly under the granite slope where he had spread his blankets. The following day, July 4, 1891, Stratton staked two claims, one named Independence, the other Washington. By the end of the century, these mines had produced over a hundred million dollars worth of gold and made Stratton one of the richest men in the world.

Different dream, different culture. One night a Ute warrior dreamed about a grizzly bear curled up in a cave in the mountains. Winter was over; the Ute knew if the bear didn't wake up soon it might starve to death. The next day he walked into the mountains and found the cave; bravely he shook the sleeping bear till its eyes popped open. Instead of attacking the Ute, the bear led him to a clearing deep in the forest where all the other bears had gathered. Arranged in parallel lines, the bears, to the thump of a drum and the rasping rhythm of a notched stick, danced back and forth, chanting and singing. "Take this back to your people," the bear told the Ute. "Teach them the same steps and songs. Tell them this is how they should celebrate the end of winter."

FACING PAGE: CALYPSO CASCADES WITH MOUNTAIN BLUEBELLS (*Mertensia ciliata*) IN BLOOM, ROCKY MOUNTAIN NATIONAL PARK

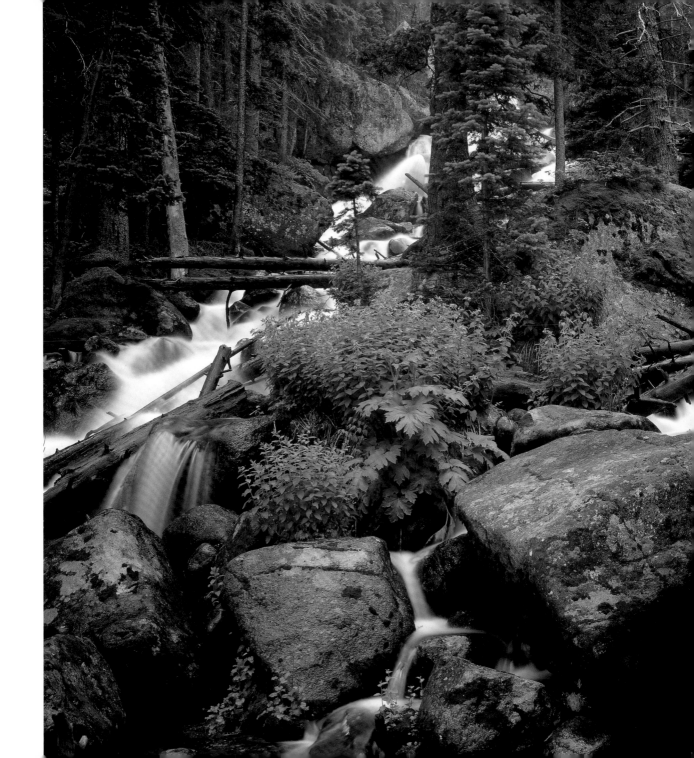

I follow a path along a narrow stream, clumped at the banks with willows, aspens and blue spruce (the Colorado state tree). How mottled aspen bark can become! Splotchy with fungus, girdled by the teeth of hungry elk and deer. Highlighted against a backdrop of olive-green ponderosa needles, the ghostly white bark glows in the misty afternoon light with an ethereal radiance. The trees look like sentinels, shrouded in smooth canvas, standing guard in the folds of this stream-fed valley.

Nature lends itself to anthropomorphization. We do it effortlessly, without really thinking. Close observation of flora and rock faces inevitably results in some degree of comparison—the known with the unknown, the factual with the speculative. Things remind us of other things, objects ramify in our imaginations; the instant we identify something, we reconfigure it. Our minds are like oceans, constantly in flux, stirring, dissolving, recharging.

Blue spruce flourish in the wetter climate of the riparian corridors. The blue tinge-ing their needles is faded and washed-out—more like a rinse than a color. The pine cones are soft, pliable, squishy; they droop from the short-needled branches instead of standing erect. I fill my pockets with them. As I walk along, I pinch and squeeze them. I even stick a couple under my hat, why I do not know.

I follow a trail that slips down a hillside to the entrance of a narrow valley. Lodged at the opening of the valley is a stack of smooth rocks. Another stream trickles under and between the boulders, curving this way and that, before debouching onto a soggy meadow. The air sweeping over the jumbled rocks smells exhilaratingly fresh; the same salubrious air that inspired Isabella Bird to declare in 1873, "The climate of Colorado is considered the finest in North America, and consumptives, asthmatics, dyspeptics, and sufferers from nervous diseases, are here in hundreds and thousands … . The curative effect of the climate of Colorado can hardly be exaggerated."

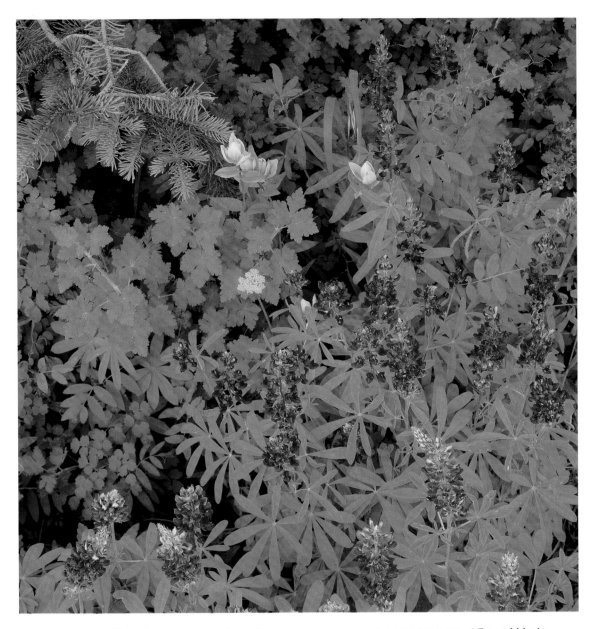

LUPINE *(Lupinus argenteus)* WITH YELLOW PAINTBRUSH *(Castilleja sulphurea)* AND YELLOW MOUNTAIN PARSLEY *(Pseudocymopterus montanus)*, WASHINGTON GULCH, GUNNISON NATIONAL FOREST

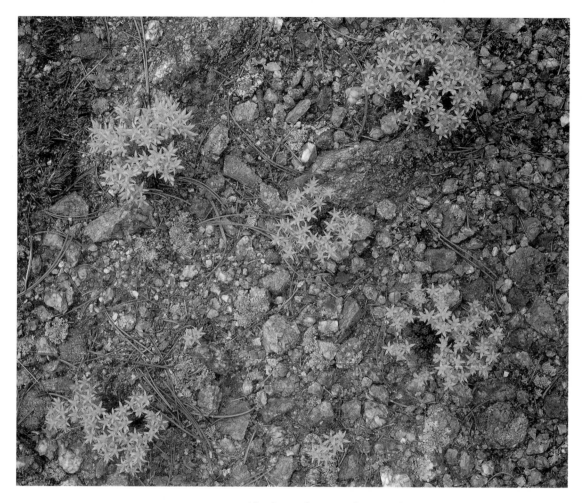

YELLOW STONECROP *(Sedum lanceolatum)* IN BLOOM,
ROOSEVELT NATIONAL FOREST

I linger at the rocks; climb up, over, around them; peer down between the cracks; stroke their lovely egg-shaped curves. They're like marbles thumbed down the hillside by a playful giant, resting now in this narrow valley at the entryway to a long wetland meadow. The meadow is threaded by a mountain stream that meanders down a series of terraced shelves to the grassy bed of what once was, fifty million years ago, a sweltering tropical lake fringed with ferns and towering redwoods.

Out in the meadow everything changes. Rife with pale, dry, swaying grasses, the ground slopes along the looping furrow of a razor-thin creek that pools across the drab surface of a beaver pond. In a few weeks, this meadow will quiver with life. Already I see dozens of ground squirrels gallivanting along the banks. What a feasting place this must be for eagles, hawks, coyotes, mountain lions, martens and bobcats. What desperate struggles must transpire amidst this rustling grass, within earshot of the prinkling creek.

Mountain wetlands are loaded with nutrients. Leaves and plant fragments, dissolved minerals from rocks, organic groundwater from adjacent meadows and forests; nowhere else are the connections between disparate life-forms so clearly delineated. The linkage is gravity driven: down from the tundra and subalpine, down from the lichen-streaked rocks and snowpacks, down from the sloping forests, down from the meadow grasses and forbs; each link augmenting the next, blending and commingling, charging and recycling. No ecosystem functions autonomously. Sully one, and you sully them all.

The wind picks up. A raft of clouds blots out the sun. Winter reluctantly loosens its grip at this altitude. A wooden bridge spans the creek—wider, more forceful here than at the portal of rocks at the top of the meadow. I stick my hand in the water—slathery, loud, achingly cold. The silvery flow sends a shiver up my wrist. Were it summer I'd be

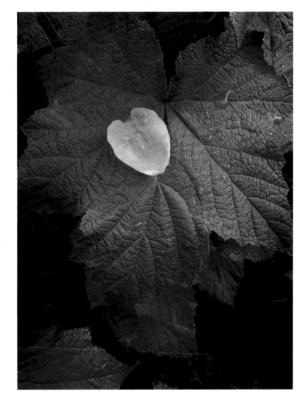

tempted to immerse my body; in mid-April, this is connection enough. I look up the valley, the long woody flanks swooping to the ridgetops and summits. I hear meltwater trickling from under the snowpacks. I hear it splash into the creek threading the meadow. I watch the creek wind out of sight through yet another meadow, down toward the foothills.

Not 5 feet from where I squat watching my fingers turn blue, two ground squirrels attack each other in a chittering fit. The shadow of a passing hawk sends the rodents scrambling for cover. Snowflakes float out of the capricious sky, followed by an outbreak of lemony sunbeams, followed by another snow flurry, which sputters out when the sun appears again. The wind sends the tips of the meadow grasses dancing like tassels from a stick. It never stops. It never ceases.

ABOVE: WILD ROSE PETAL,
WHITE RIVER NATIONAL FOREST

JUNIPER *(Juniperus communis)* IN ICE,
FLORISSANT FOSSIL BED NATIONAL MONUMENT

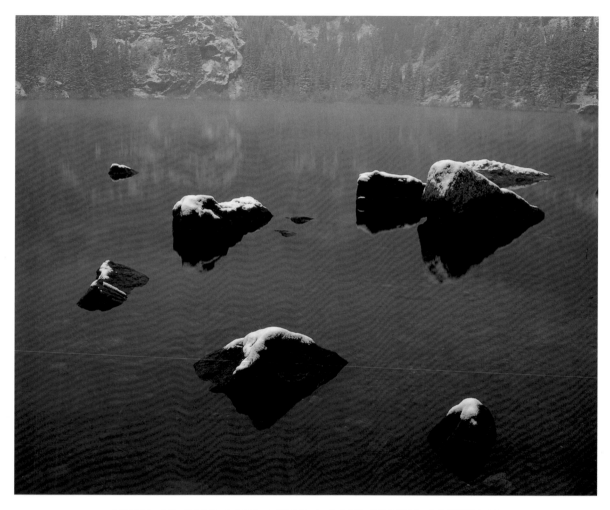

ROCKS IN BEAR LAKE AFTER A LATE SPRING SNOWFALL

FACING PAGE: WATERFALL IN EARLY WINTER, NORTH FORK, BOULDER CREEK

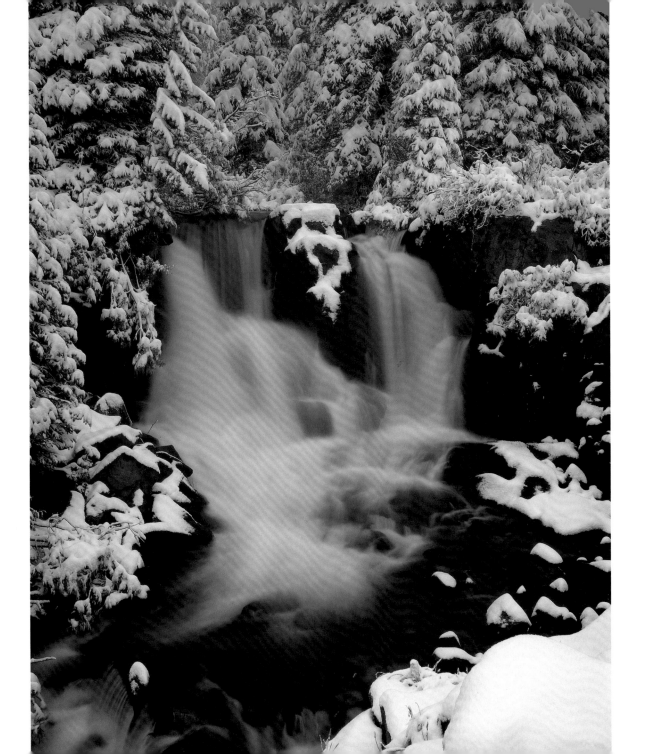

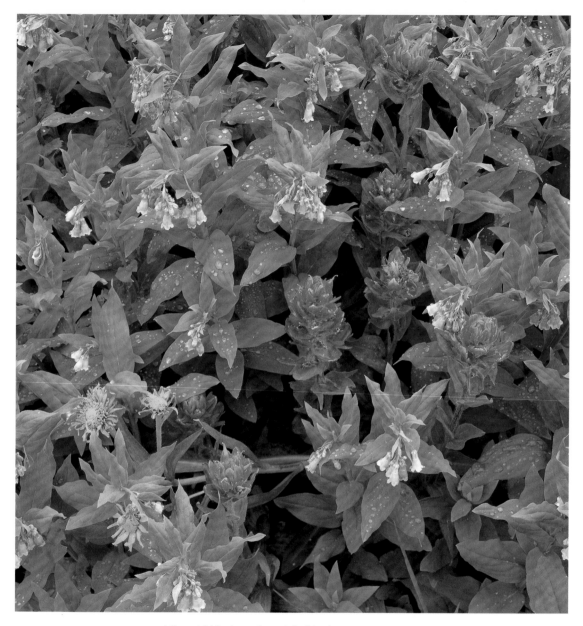

ROSY PAINTBRUSH *(Castilleja rhexifolia)* AMIDST MOUNTAIN BLUEBELLS
(Mertensia ciliata) AFTER SUMMER SHOWER, YANKEE BOY BASIN,
SAN JUAN MOUNTAINS, UNCOMPAHGRE NATIONAL FOREST

IV
Subalpine

The Engelmann spruce–subalpine fir forest is instantly recognizable by its density, narrow crowns and dark green color. The ecosystem forms the highest, continuous, pristine growth in Colorado. Present from 9,000 feet to the timberline, the trees are most abundant between 10,000 and 11,000 feet.

It's cool at these elevations, windy and moist. Snow falls in heavier quantities than in any other mountain zone. Shaded from solar radiation by an interlocking canopy, snowpacks linger well into summer, later than those found on the alpine tundra. The growing season is limited to the frost-free months of July and August.

Protected from fires by the moist climate, too remote for serious logging, the subalpine ecosystem has remained remarkably intact; some trees, over four hundred years old, stand 120 feet tall. Spruce-fir forests are climax ecosystems; since no other tree in the Colorado forest can reproduce itself in the shade at these altitudes, they continue to dominate.

The zone of transition between the dense subalpine forest and the alpine tundra is known as krummholz (a German word for "crooked wood"). Under pressure of the thin air and frigid cold, trees at the upper limit of the subalpine forest diminish in size. Steady winds stunt their growth, producing "flag trees," characterized by a lopsided branching on the leeward side.

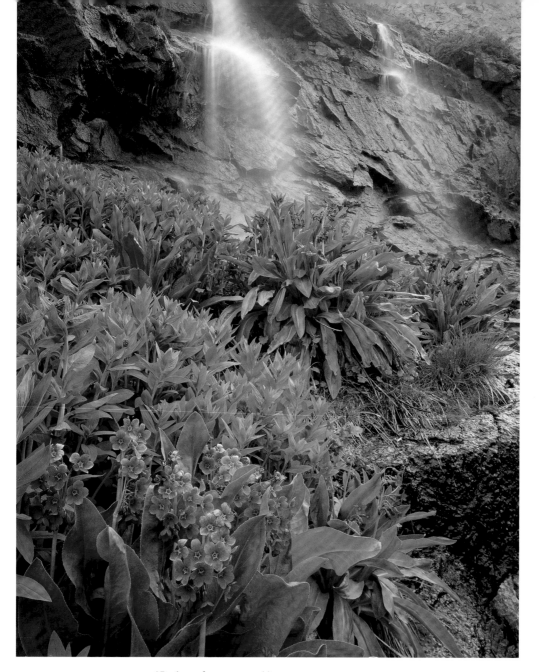

PARRY PRIMROSE *(Primula parryi)* IN BLOOM BENEATH WATERFALL,
SANGRE DE CRISTO WILDERNESS, SAN ISABEL NATIONAL FOREST

It's time to reach out to the tops of these formidable mountains. A flatlander, drawn to subtle swells and undulating vistas, I approach this task with trepidation. It's cold up there, the snow stacks high, the wind blows bitter and harsh. I've heard rumors of bears.

Crags Campground, just south of Mueller State Park, on the road to Cripple Creek. I'm walking through subalpine forest on a shady trail slick with crusty slabs of ice. It's quiet in the depths of this dense forest, cloistered, snug. The wind hums through the tops of the trees. The forest at this elevation, over 10,000 feet, is composed of Engelmann spruce, subalpine fir and aspen groves. Tall trees, crowded together, soaring up toward the sky, as if racing to touch the sun; masses and masses of them, with straight trunks, shaggy branches and pointy crowns, lacing the steep hillsides like strips of filigreed ribbon.

A chickaree (red squirrel) dashes across the path startling me, bringing my gaze back down to my feet. Small, dark, compact, with a flimsy gopherlike tail. I hear it chittering somewhere behind a fallen trunk: peevish, vexed, irritated at something, most likely my intrusive presence.

The trail winds up through a narrow valley marked with pale yellow meadows, tall aspen trees, piles of cracked and rounded rocks. A glacial finger boring through this valley thousands of years ago thumbed and prodded these rocks into the positions they

occupy now. From a distance the rocks look smooth; wind and water have abraded them into a variety of appealing shapes. The smaller rocks perched precariously at the top appear ready to tumble down at the slightest tremor or nudge.

I'm in the granite heart of the mountains now. Chilly, contained, deeply forested and steep. There's no sense of transition here as there is down in the montane, with its lush meadows and spacious forests. Everything is tighter here, closer, more confined. The wind sweeps the rocks, the pointy crowns of the conifers, with the teeth of a metallic comb. The thin air is bracing and cool—a liquid, silvery solution that my lungs eagerly inhale. The sun is certainly more dazzling: febrile, radiant; I see the hulking bearlike outline of my bulky shadow against a snowbank.

The aspens in the meadows are tall with swollen trunks and attenuated limbs. They stand closer together than in the groves down in the montane. They thrive along the south-facing slopes—the product of sunlight and a nutrient-rich soil that receives plenty of water year-round from snow and rain. The signature silver-gray bark is splotched with bird pecks, browse marks, insect infestations. Standing at a distance, surveying the entire grove, they seem to form a secret code, indecipherable to those who lack the key.

Subalpine forests support fewer animals than the montane. Lingering snow cover restricts their movements, while the short growing season limits the variety of berries and seeds in the understory. The closely packed trees offer little browse for mule deer and elk.

Common mammals include pine martens (arboreal weasels that feed on pine squirrels), red-backed voles and deer mice. Other species include the snowshoe hare (a nocturnal, solitary animal that changes color from brown to white with the seasons), the Canada lynx and the carnivorous wolverine (these last two are rarely seen).

STICKY GERANIUM *(Geranium viscosissimum)* AFTER MORNING FROST,
SANGRE DE CRISTO WILDERNESS, SAN ISABEL NATIONAL FOREST

And bears. In the mud next to my boot I see, unmistakably, the paw print of a bear. That same instant I hear a chuffing sound in the shrubs behind my back. I turn. My shoulders cringe; the hair prickles on my neck. *Chuff chuff. Chuff.* Then nothing. I tighten the grip on my hickory stick. What's the procedure for ensuring a successful encounter with a black bear? I can't remember. It doesn't matter. I'm certain to panic anyway: yelping, whooping, fleeing down the path. The wind agitates the shrubs, stirs the grasses. The sound I probably made up, though not the track, which, clearly outlined in a glop of rust-colored mud, looks real enough. This portion of the subalpine forest feels like bear country. *Chuff chuff.* They're waking up now, all over the Rockies. Stirring, stretching, yawning. Getting their heart rate back to normal, up from an average of eight beats a minute during hibernation. Thinking about food, about restoring the one-quarter of their body weight they lose while sleeping. Growling, moaning, sucking their left paws. Tender and gelatinous, bear paw is a delicacy prized by people all over the world, especially in Asia, where its putative aphrodisiacal properties encourage a contraband trade.

In 1905 President Theodore Roosevelt went bear hunting in Colorado. Armed with a Springfield 30–40 caliber rifle, primed with soft-nosed bullets—"a very accurate and hard-hitting gun." Accompanied by twenty-six hounds and four terriers, TR and his party chased black bears up and down the slopes, through remnants of April snow similar to what I encountered. One morning, on the far side of a gully furrowing a steep mountain, the dogs bayed a big male, crowding it so close TR despaired of squeezing off a shot. Finally, as the bear slid under a piñon, he obtained a clear view of its "rounded stern." The shot broke both its hips. Down to the bottom of the slope the bear tumbled, followed by the clamoring dogs, followed by TR on the other side of the gully. At the bottom, as the bear rose on its forelegs to fend off the dogs, TR delivered the coup de grace, a well-placed shot between the shoulders that broke the bear's back.

The creature weighed 330 pounds. There was nothing in its stomach, indicating that it had been but a little while out of its winter den. Had it been autumn, says TR, fattened up for sleeping, the animal's avoirdupois would have exceeded 400 pounds. There's a photo of the president, clutching the barrel of the bolt-action Springfield, looking down at the dead bear through his famous pince-nez.

At the end of the valley I start up a steep incline through drifts of stacked-up snow. Snow collects in the subalpine, not only from intense fallout, but down from the tundra in wind-driven sheets that catch between the trees. The going is tough. I pause frequently to calm my thumping heart. The sound of water tinkles melodiously in my ears. Water draining out of the snowpacks, curling downhill from every direction. High up in the trees the wind furls, sighs, shivers and creaks. Limbs grind together with protracted groans. There's so much going on here that I simply can't fathom. A fallen Engelmann spruce lying athwart a patch of snowless ground is slowly returning itself to earth. The barkless trunk has split down the center, exposing the core, assailed by innumerable organisms, converting the wood to mulch. Bit by bit, increment by increment, trunk, branches, twigs, bark collapse under the weight of implacable decay. The process is relentless, fragments of a complex pattern feeding back into each other, folding, dissolving, reforming. No matter how closely we examine nature, more detail will always be revealed. Such detail, keenly observed, eagerly recorded, makes us endlessly hungry for more. Thoreau showed us the way in his journals. There's no such thing as a closed system in nature.

A few minutes later I am rewarded with a splendid view at the top of a rock outcropping. To the west I see the snow-mantled peaks of the Continental Divide; to the north a spacious valley containing a trio of impounded lakes. To the east the jagged profile of the Front Range, and beyond it, as far as my eye will carry (all the way to the St. Louis Arch!), the tawny swath of the plains.

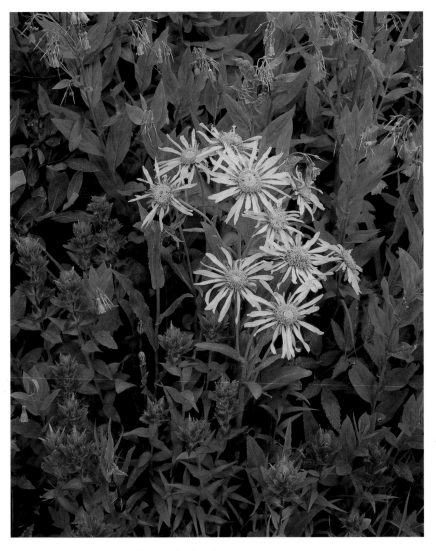

ORANGE SNEEZEWEED *(Dugaldia hoopesii)* WITH ROSY PAINTBRUSH *(Castilleja rhexifolia)* AND MOUNTAIN BLUEBELL *(Mertensia ciliata),* SAN JUAN MOUNTAINS, UNCOMPAHGRE NATIONAL FOREST

FACING PAGE: TWIN FALLS, YANKEE BOY BASIN, UNCOMPAHGRE NATIONAL FOREST

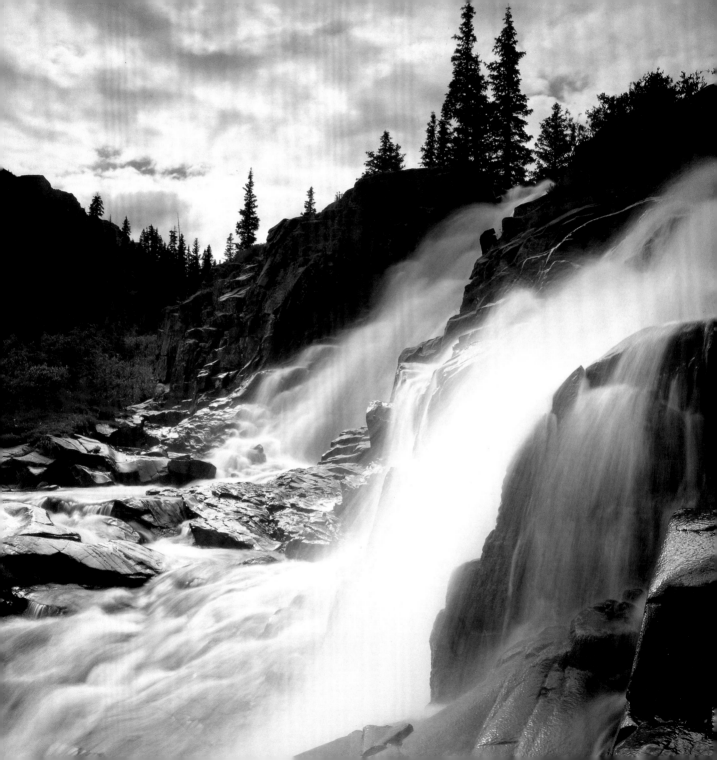

The view is stupendous. I am transported out on the curve of my eye, seemingly around the curve of the earth itself, a long soaring parabolic line that returns me to the spot where I stand now. Bending down, I see, against a patch of glimmering snow, a solitary yellow-brown aspen leaf the size of a quarter. Carried here, presumably, by the wind (there are no aspens anywhere around); threaded with spidery white veins fanning out in asymmetrical order to a serrated oval rim.

Overhead: clots of filamented clouds scudding under a transparent sheet of high-soaring cirrussy ones.

To my right a limber pine, an indication that I'm nearing the upper limit of the subalpine zone. Bushy clusters of pliable needles at the tips of the flexible limbs sway back and forth in the steady wind. Another few hundred feet and the subalpine fades at the timberline. Scanning with my binoculars, I spot several "flag" trees, their branches crooking paralytically downslope. I see patches of *krummholz,* "crooked wood," gnarled and crabbed, pressed close to the earth, last gasp of the mighty mountain-tree system before it's permanently thinned by the punishing alpine climate.

My blood sugar has dropped. Stupidly I clambered all the way up here without water or food. I'm getting irritable. It's time to climb down. Slowly, chuffing like a bear, I stagger down through the trees, scooping up handfuls of snow, letting them melt in my mouth, hoping to fool my stomach into thinking that something satisfying is on the way. Bear paw. Halfway down, trotting through a meadow, trembling with fatigue, I chew the smooth pads of my left hand, growling, mumbling, tasting sweat, grit, snow, the acidic tang of pine needles.

SHADOW ON SNOW,
GUNNISON NATIONAL FOREST

FACING PAGE: DEW COVERED GRASS, MAROON BELLS—SNOWMASS WILDERNESS

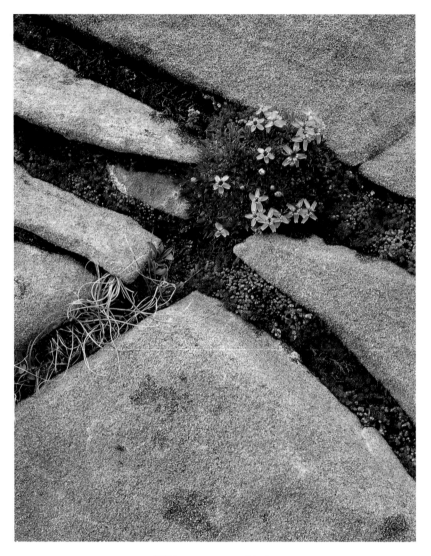

MOSS CAMPION (*Silene acaulis*), HASLEY BASIN,
MAROON BELLS–SNOWMASS WILDERNESS,
WHITE RIVER NATIONAL FOREST

V
Alpine

The Colorado Rockies boast fifty-four peaks with summits reaching over 14,000 feet. Alpine tundra starts above the timberline, at around 11,200 to 12,000 feet, and extends all the way to the top, however high that might be.

There's more biological life at these heights than one might imagine. Annual precipitation measures between 40 and 60 inches, most of it falling in winter as snow. The fertility of the soil at these elevations varies from place to place. Those ridges untouched by the scouring force of the mighty glaciers that once covered portions of the North American continent frequently contain deep pockets of residual soils that support thriving populations of shrubs, plants and forbs. Lush meadows, filled with sedges and grasses, populated with marmots, pikas and voles, alternate with rock fields partially colored with lichens and mosses.

The climate is severe. The growing season lasts maybe a month and a half. Year-round the slopes and summits are buffeted by ferocious winds, at times exceeding 100 miles per hour. The lack of oxygen accentuates the radiant energy of the sun. Up here there are no trees, only a kind of pygmy vegetation—plants, shrubs, flowers (often brilliantly colored)—measuring a scant few inches in height. The biota is streamlined for survival—dwarfed, stunted, with a capacious root structure—to minimize exposure and conserve energy.

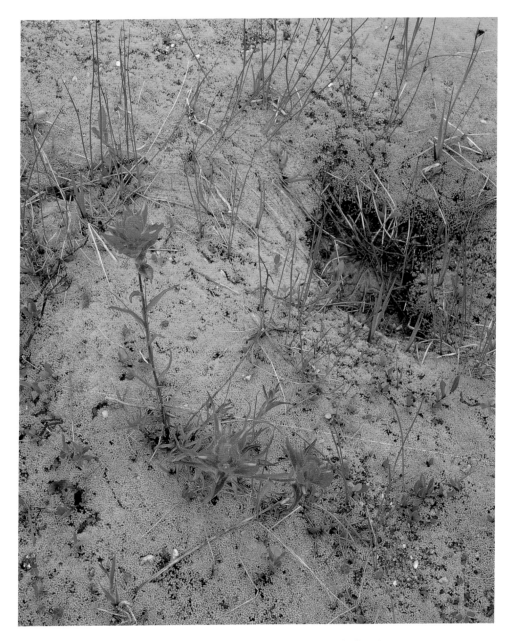

INDIAN PAINTBRUSH *(Castilleja linariaefolia)* GROWING ON
MOSS, ARAPAHO NATIONAL FOREST

The first Colorado mountain I ever stood on top of was Pikes Peak. One afternoon my brother and I put the top down on our father's 1970 Buick Skylark convertible and roared up the dusty, graded road to the summit. The frigid air turned our eyes to gelid pools; our hair was spiked and twisted, our cheeks chapped and red. It was freezing at the top; the air was thin; I felt light-headed and dizzy. Way off somewhere in the folds of the foothills I could see the murky smear of Colorado Springs, the fuzzy network of roads leading in and out looking like scorch marks on a slab of beef.

A raven drifted by, casting a creaky shadow over the rock fields and snowbeds. It was the first time I had been above treeline without being in an airplane. I was impressed by how empty everything was: lonely, desolate, cold; the perfect backdrop for a Samuel Beckett play. A chill rippled through my body, and not just from the icy wind. I felt lost in that immensity, a speck of puny consciousness poised at the tip of a wild, forbidding world.

Mountaintops usually elicit more favorable responses. In the summer of 1868, Samuel Bowles, editor of the *Springfield* (Massachusetts) *Republican*, recorded his first impressions after scaling Grays Peak in central Colorado. "The scene before us ... was the great sight in all our Colorado travel. In impressiveness ... it ranks with the three or four great natural wonders of the world ... No Swiss mountain view carries such majestic sweep of distance, such sublime combination of height and breadth and depth; such uplifting into the presence of God ... It was not beauty, it was sublimity"

Ten years later I went up Pikes Peak again, this time in the cog railroad that winds out of the little station in Manitou Springs. The cars that warm summer day were packed with vacationers: portly Midwesterners in matching windbreakers and ballcaps; a party of middle-aged Germans wearing leather shorts much too revealing for their flabby, blue-veined thighs; sullen teenagers with green- and carrot-colored hair, dressed in pantaloonlike trousers and paint-spattered shirts, their lips, ears and noses spangled with tarnished rings.

The journey took about an hour and passed through four ecozones: foothills, montane, subalpine, alpine. (I had done my homework; I was equipped with guidebooks.) To the east, a fifth, plains, was shimmeringly visible—all within the lateral span of a mere few miles. As the train tootled out of the station, magpies, harlequinesque in their sleek black-and-white plumage, gamboled between scaly orange ponderosa trunks. Higher up I spotted flickers, Steller's jays, mountain bluebirds and Clark's nutcrackers.

It was fun looking out the window, watching the vegetation change. Feeling nostalgic for their native Alps, the Germans burst into rousing song. The Midwesterners gazed down awkwardly at their calloused fingers. The young people snorted and scoffed and ran their fingers through their remarkable hair. I pressed my nose to the glass. Above the treeline, around 11,500 feet, a scant few yards from the creeping train, I saw undulating lawnlike meadows covered with wildflowers. These were the kobresia communities, regularly tilled by pocket gophers, verdant and lush despite the abbreviated growing season, consisting mostly of flowers (alpine sunflower, alpine primrose, alpine wallflower) and narrow-leafed sedges—tasty fare for the Rocky Mountain elk that feed at the tundra's edge each summer.

A few of the wetter meadows contained vegetation such as marsh marigolds and dwarf willows, the tallest perennial treeline organism. One or two of these meadows

looked as if they were about to shake loose and slide downhill. Solifluction terraces, they're called—moist on the surface, frozen underneath, a product of improper drainage.

Higher up were the fellfields: shattered rocks scattered across flat surfaces, interlarded with accumulations of soil. These rock fields are usually located on exposed slopes where high winds whisk them free of snow, leaving little moisture for plant growth.

Cushion plants survive here, so-called because their low-growing masses of stems, roots, leaves and flowers resemble large pincushions. Plants at these altitudes conserve energy by using the same root masses year after year; ninety percent of the total structure of some tundra biota consists of subterranean roots. The hemispheric shape of the cushion plants is ideal for heat retention.

Location is everything in nature, but especially in the alpine tundra. Unlike the lower forests of the montane with their variation in slope exposure, there's not much room up here for plants to maneuver; they must take firm hold, or they won't survive. Snow depth is a factor: how fast the snow melts or is blown away by the wind. Exposure to the sun is another; also whether the plant is positioned properly to receive adequate downslope drainage, or too much. Elimination is swift and ruthless. Biological forms labor here under the severest constraints.

Nature is nothing if not opportunistic. Cracks in the rocks at high altitudes offer potential oases. Water seeps into the cracks and freezes. The crystalline structure of the ice acts as a wedge, fracturing the rock. Wind-borne particles settle inside the cracks. Soil collects, deep enough to nurture the seeds of such flowers as the moss campion.

The harsh climate, ferocious winds and thin air make for a short growing season, July 1 to mid-August. Flora damaged by natural acts or careless hikers takes a long time to heal. A community of cushion plants can require as much as two decades to recover

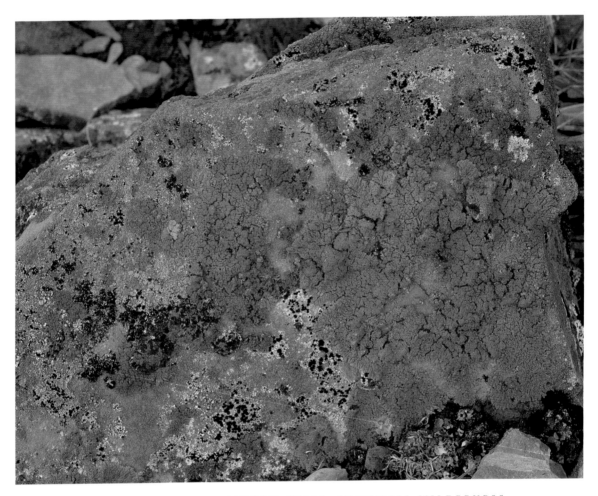

LICHEN ON ROCK, MAROON BELLS–SNOWMASS WILDERNESS,
WHITE RIVER NATIONAL FOREST

from a single summer of human foot traffic. The biota here are made up mostly of climax communities, resistant to invaders, slow to mature, even slower to accommodate change. Everything slows down at this altitude, except the heart rate of the people who venture into it.

Debarking from the train, I walked around the parking lot where my brother and I had stood a decade earlier. Tattered clouds sailed across the summit; a cold wind whistled around the corner of the gift shop. Snowpacks lay scattered around the slopes like bales of old newsprint. Once again I had reached the top of the world, and how exactly did I feel? Vulnerable, exposed and uneasy. Like Jack at the top of the beanstalk. Marooned and isolated, with nowhere left to go.

Katharine Lee Bates wrote the poem "America, the Beautiful" in 1893 after an excursion to the top of Pikes Peak. I wasn't looking for that kind of inspiration; all I wanted was to feel connected to where I was.

On Owens Mountain near Crested Butte, two weeks after my cushy Pikes Peak ascent, traveling alone, weary and footsore, I paused to examine an outcrop of lichen on a slab of pale rock—like flaky bits of paint chips, curled at the edges, brittle and dry. Colorado has over 450 species of lichen; they're found on nearly every rock in the alpine zone, feeding on windblown debris, random moisture, minerals in the rock itself. In terms of complexity, they occupy the bottom rung of the biological ladder. Lichen are symbiotic, composed of both alga and fungus; they survive primarily on photosynthesis manufactured by the alga.

That night, huddled in my flimsy tent, rocked by howling winds, I read a Ute Indian tale in the quavery beam of a pocket flashlight. A terse exchange between Wolf and Coyote that could have been scripted by Samuel Beckett.

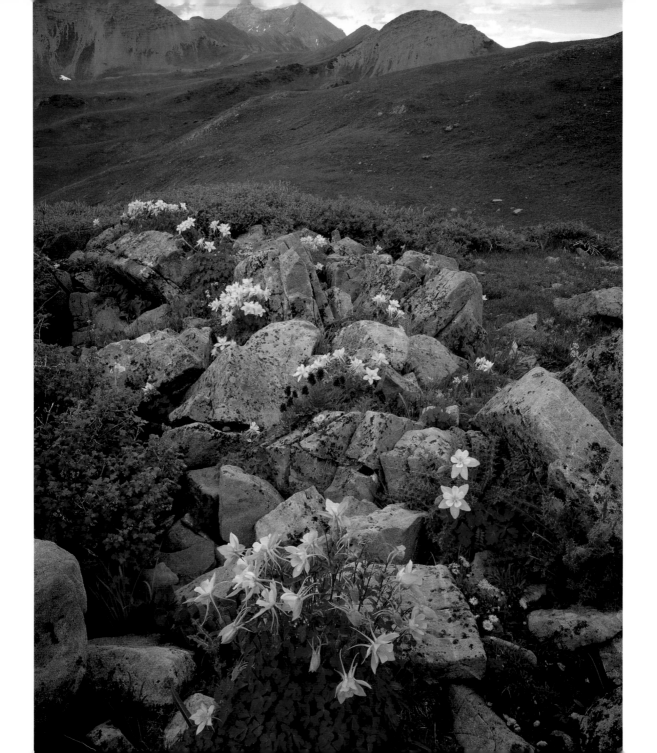

Wolf wanted women to carry babies in their arms and suffer no pain.

Coyote said, "Let them bear children in their abdomens

and suffer lots of pain." Wolf wanted the dead buried in anthills.

He wanted them to come back to life the next day.

Coyote said, "Stick them in the ground.

Let the families cut their hair. Let them be sad and cry."

Wolf wanted to eliminate winter. He wanted the weather

always to be nice.

Coyote said, "Let it be cold all the time. Really cold."

The wind blasted the tent flaps, threatening to pluck the pegs out of the frozen ground. I uncapped my flask of Jim Beam and took a long, consoling swig.

I suppose I need to confess something. I'm leery of mountains. I find them oppressive and claustrophobic. They curdle my vulnerable flatland soul. Even at the top, with all that distance unraveling between my eye and the horizon, I feel detached, diminished, ill at ease. The guidebooks helped, the histories, the first-person accounts; but something was still missing.

You can drive to the top of Mt. Evans (14,264 feet), the highest auto route in the United States, first engineered in 1930. Above the treeline with two friends one gusty late-May afternoon, we saw meltwater glistening darkly against the gritty, pulverized, granite slope—tumbling, gurgling, flowing like a hemorrhagic wound, loosened by the bright spring sun.

At Summit Lake, in the teeth of a bitter northwest wind, we walked the short trail from the shelter cabin along the edge of an icy tarn. Cloud shadows scudded over the

FACING PAGE: COLORADO COLUMBINE *(Aquilegia caerulea)*,
ABOVE HASLEY BASIN, MAROON BELLS–SNOWMASS WILDERNESS,
WHITE RIVER NATIONAL FOREST

face of the frozen water. A yellow-bellied marmot lounged on a dry rock. In summer, marmots accumulate large fat reserves to carry them through hibernation, in contrast to pikas who store food for the winter. They lie around like furry sausages, sleeping, snoozing, conserving energy, emitting loud warning whistles when strangers enter their territory.

At the overlook we gazed down into a steep cirque that plunged into the Chicago Lakes Valley, a glacially carved, shelflike sequence containing the famous "paternoster" lakes, so-called because of their resemblance to a string of rosary beads. Each tarn was edged with ice and snow, bounded by stony gray walls. The perspective was astounding—as if a blueprint of the erosive path of an Ice Age glacier had been unscrolled at our feet.

The forbidding tundra was slowly coming into focus for me. Too much staring off into space from the summits and passes of stratospheric heights, too much brooding on my own human fragility, had created a vacuum at the center of my consciousness. I needed a handle, something concrete, a solid peg, on which to fasten.

Where to start? The spring tundra of Mt. Evans offered a host of possibilities. The alpine primrose, for example. One of the first high-altitude flowers to bloom, with a cluster of magenta-colored petals radiating from a yellow eye. Fourteen blossoms by my count (down on hands and knees, glasses off, eyes squinched, like a jeweler examining a precious gem). Connected by subsurface branches; bearing scoop-shaped leaves like Chinese soup spoons to snag the slightest drop of moisture from the air.

A few feet away, an alpine avens. The finely dissected fernlike leaves contain high quantities of anthocyanin—an antifreezelike pigment that protects plants from tissue-damaging ultraviolet radiation by absorbing and transforming radiation into heat. As fall approaches and the green chlorophyll pigments decompose, the anthocyanin shines forth, painting the tundra in hues of ruby red.

SNOW BUTTERCUP *(Ranunculus adoneus)*, NEAR LAKE ISABEL,
INDIAN PEAKS WILDERNESS, ROOSEVELT NATIONAL FOREST

Even on the windiest days an insulating layer of calm air hovers over the alpine soil. The boundary layer, scientists call it. The sun heats soil, rocks and vegetation, which, in turn, warm the air of the boundary layer, creating a microclimate as much as 20 to 30 degrees warmer than the air a few feet higher. So long as plants remain small enough to fit into this specialized zone, conditions for survival, though perilous, are not necessarily fatal.

What could be more lucid and appropriate than the ways these organisms have adapted to the rigors of alpine life? And not just adapt, but thrive with flair, color, persistence, with a kind of complex willfulness? Near the summit of this remarkable mountain, offering views on a clear day a hundred miles away, I was replenished by the sight of a tiny yellow flower, barely 2 inches high, constrained by the severest limitations, thriving with tenacity and intelligence. "The pure joy of the mineral fact," says poet George Oppen. I smiled as the car swung down the mountain. I smiled through dinner and all the way into the next day.

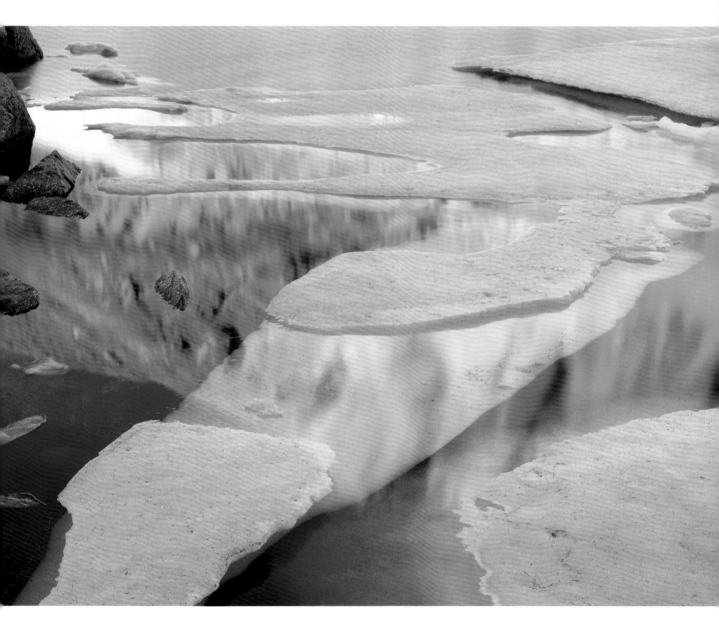

MELTING SNOW AND ICE IN BLUE LAKE,
INDIAN PEAKS WILDERNESS, ROOSEVELT NATIONAL FOREST

TWINPOD *(Physaria newberryi)*,
COLORADO NATIONAL MONUMENT

Desert

The geologic history of western Colorado begins about three hundred million years ago with the orogenic uplift of the ancestral Rocky Mountains. To the east, in the region of the present-day Rocky Mountains, the earth's crust buckled and cracked under pressure of a convulsive upwelling of metamorphic rock. As quickly as they formed, the peaks and slopes weathered away, sending massive amounts of debris sliding down to the lower elevations.

In western Colorado the process was different. The very old (1.6 billion years) gneisses and schists of the Precambrian Formation were elevated ever so slowly, like a stack of pancakes on a plate. This uniform process of uplift on a grand scale involving minimal folding, faulting and tilting is known as epeirogeny. Erosion followed, more sediment was deposited; around seventy million years ago another great uplift (in conjunction with the creation of the present-day Rocky Mountains) elevated many of the older West Slope formations, including the Uncompahgre Plateau, where Colorado National Monument is located. The process of erosion accelerated during the Ice Age, when the climate of the Southwest was wetter and more water poured down through the canyons than does today.

The Continental Divide swings down through the center of Colorado, north to south, in a winding vertical line. West of the divide, Interstate 70 dips out of the dense forests of the Rockies down onto the high mesas, fertile valleys, jagged canyons and rolling shrublands of the West Slope. The Colorado River, fresh from its source at Lake Granby in the north-central part of the state, cuts down through Glenwood Canyon, carving a deep trench between high walls. The canyon is a rite of passage for any west-going traveler, linking mountains to high desert, deep woods with arid canyons.

Shrublands dominate the landscape north of Grand Junction along the western boundary of the state: big sagebrush, greasewood, saltbush and rabbitbrush. It's a land of open skies, wild horses, dinosaur bones and tumbleweed—the least known and least visited corner in Colorado. Precipitation is minimal, less than 10 inches a year in some places, falling mostly in winter. The soil is mainly Mancos shale, deposited during the Cretaceous Period, full of silt and clay; the little rain that falls runs off the surface rather than penetrating to any depth.

Sagebrush rolls for miles over the low ridges and hills in shimmering blue-gray carpets. Big sage, the most common, belongs to the sunflower family. Historically the land, like so much of the West, was heavily grazed by cattle and sheep. Cattle don't care for sagebrush, preferring the herbaceous understory instead, which disturbs the soil between the plants, making room for more sage. Sage also provides an important

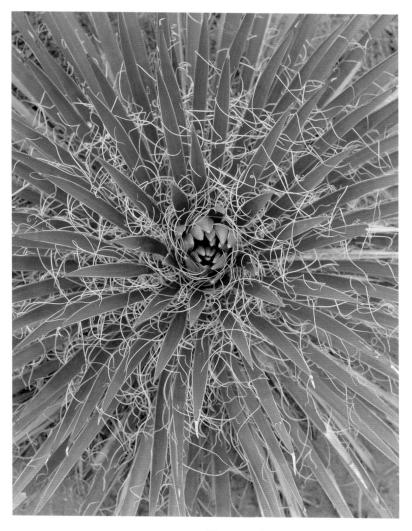

NEW MEXICO YUCCA *(Yucca harrimaniae)*,
COLORADO NATIONAL MONUMENT

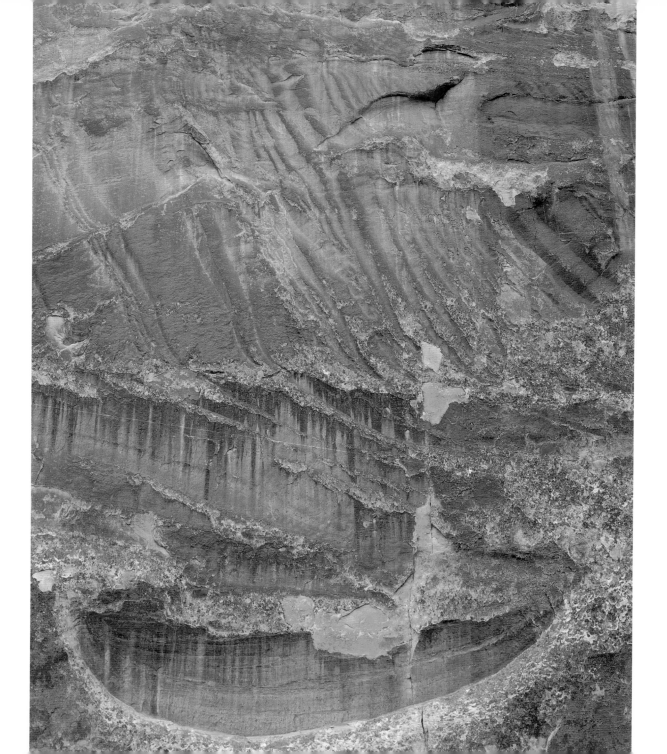

browse for mule deer and pronghorn antelope, as well as cover for smaller animals and birds.

The Morrison Formation around Dinosaur National Monument yields many remains from the Jurassic Period, but oil shale is probably the region's most distinctive geologic feature, and that's found in the Mancos Formation, a more recent sedimentary deposit. It's estimated that there are 288 billion barrels of recoverable oil locked away in Mancos Formation shale in the northwest corner of Colorado—enough to satisfy the nation's domestic needs for fifty years.

A primitive recovery operation was first initiated near the town of De Beque, Colorado, in 1917. Since then the region has experienced several boom and bust periods, most recently in the 1980s. Shale heated to high temperatures breaks down a hydrocarbon known as kergon, converting it to petroleum. Some oil shale rocks are composed of 20 percent kerogen and can produce, upon treatment, as much as 100 gallons of oil for each ton of processed rock.

My destination was Colorado National Monument, located just south of I-70, notched high up in the northeast corner of the Uncompahgre Plateau. Water, seeking the path of least resistance to the fertile valley below, has chewed through the plateau rim, carving jagged canyons and solitary monuments. The sandstone walls are streaked with draperies of rusty black desert varnish (natural seepage that oxidizes upon contact with the air). The surfaces of these sedimentary layers are cracked at right angles by irregular lines, indicating the pattern in which they will continue to erode.

I'm on the edge of canyon country, a few miles from the Utah state line, perched at the rim of the Colorado Plateau, a vast, uplifted, geologically complex region occupying a sizeable portion of four states in the American Southwest. A legendary place, shapely, colorful, full of dazzling shapes and formations, smoothed and twisted by wind and

water. In few other places has the earth's protective verdure been stripped so consistently to reveal the relentless process of accretion and erosion by which the crust of the earth has refashioned itself over the eons.

Ute Indians, whose original territory extended from the Colorado Front Range well into eastern Utah, have their own version of how this region came to be. A long time ago the chief of all the Utes lost his wife. Day and night he grieved, and the people were sad. The chief undertook a difficult journey to the southwest where his dead wife had gone. A ball of fire rolled ahead of him, gouging a hole through the earth and mountains. The ball was easy to follow, and the chief soon found himself in a strange and beautiful land. When he saw how happy his wife was, he decided to stop grieving. To prevent him from ever following that trail while he was still alive, the spirits rolled a river down through the trail, a mad raging river, that roared and frothed between the canyon walls, making passage virtually impossible.

The desert air at 8:45 this pleasant June morning as I traipse along Otto's Trail in Colorado National Monument is lucid and transparent. Buzzards wheel overhead. A raven croaks with territorial emphasis. Big sage with silver-gray leaves and dusky black branches, looking ghostly and evanescent, grows everywhere at the tops of these rim-rock formations.

Mormon tea flourishes in wiry clumps. Stiff, bristly, jointed green stems—a definite indicator, along with sage, of a high-desert habitat. Distilled into a tea, the liquid provides an antidote to pollen allergies. Native people have long used it as a diuretic.

The rimrock is splotched with pockets of gritty red soil in which big sage and Utah juniper have managed to take root. Along with the juniper, the leaves and stems of the big sage have been used in ceremonies by the prehistoric Anasazi to the present-day Utes, both as a disinfectant and an elixir to cleanse the air of pernicious spirits.

SNOW MELTING ON SAND,
GREAT SAND DUNES NATIONAL MONUMENT

Potholes gouge the rock, laced with scummy water, streaked and dotted with airborne seeds, filaments, tufts and other debris. The devices developed by organisms in this aridity to retain moisture are efficient and shrewd: hairy stems, wiry branches, spiny pads, waxy leaves; or, in the case of Mormon tea, no leaves at all.

Ravens are the boss of the rimrock. Swallows, too, but especially the big black corvidaes sailing overhead. Their vocal talents are remarkable. They croak, honk, puff, chirr. They hiss like cats. They expel gassy tubalike burps. They're curious, inquisitive, brash. The points of their glossy black wings stick out like fork tines. *"Hownt! Hownt!"* I hear one call. *"Urrk! Urrk!"*

The view to the north and northeast from the edge of the Otto Trail Overlook is superb, taking in a generous swath of the Grand Valley and Colorado River. Green fields and orchards radiate out from the town of Fruita. Agriculture, limited to modest plots and orchards, thrives down in the valley; unlike the dreary fields of the Midwest, plowed fence to fence like parking lots, there's no monoculture here. Grand Valley and Colorado National Monument pose an interesting contrast between conflicting forms of land use: fertile valley versus stony wilderness; communal security versus solitary adventure.

The trail is named after John Otto, a genuine hero in these parts, so far as conservationists are concerned. He first came to western Colorado in 1906 and began exploring the rimrock edge of the mesa above Grand Valley. "These canyons … feel like the heart of the world to me," he wrote to a friend. "I'm going to stay and build trails and promote this place, because it should be a national park." A fervent socialist and patriotic booster (such opposites were easier to reconcile in those days), he lobbied vigorously for preserving this corner of the Uncompahgre Plateau as a national monument. When the dream finally came true in 1911, Otto was hired as its first custodian for a dollar a month.

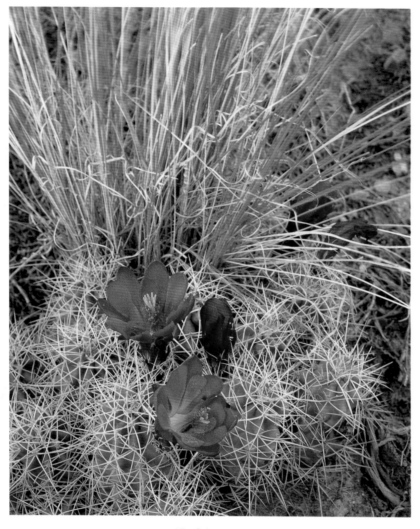

CLARETCUP CACTUS *(Echinocereus triglochidiatus)*
IN BLOOM, COLORADO NATIONAL MONUMENT

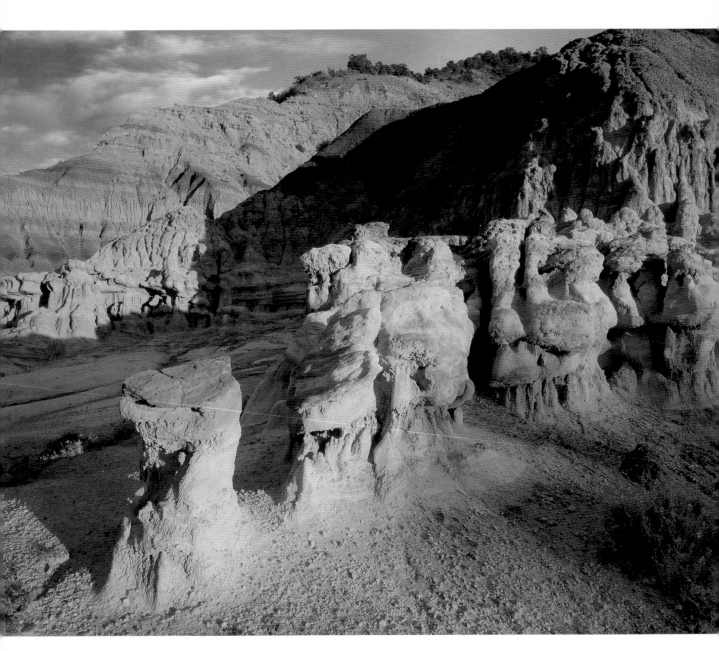

GOBLIN FORMATIONS, BLM LANDS,
WESTERN COLORADO

In 1910 he married a woman from back East named Beatrice Farnham. The marriage dissolved after a few months; the lure of the outdoors remained too strong for Otto. "I tried to live his way," she sighed, "but I could not do it. I could not live with a man to whom even a cabin was an encumbrance."

Like Everett Reuss, like Ed Abbey, John Otto craved the absolution of desert solitude. The isolated reefs and secretive canyons of the Colorado Plateau are profoundly appealing to the solitary individualism of the American psyche. Any foreigner wishing to understand us needs to come out to the Southwest for awhile.

South of Grand Junction the Mancos and Morrison Formations have been stripped away leaving a cross section of earlier sedimentary layers clearly viewable from various places along the Rimrock Road that threads the length of Colorado National Monument. Standing at Coke Ovens Overlook, it's easy to identify the prominent strata: Entrada, Kayenta, Wingate, Chinle, in descending order of antiquity, reaching from above the road all the way down to the canyon floor.

Entrada, the topmost layer, is a reddish sandstone that weathers beautifully to smooth rounded forms known as "slick rock." This layer composes the majority of the natural arches found on the Colorado Plateau, especially in Utah's Arches National Park, 50 miles west.

Kayenta is the next layer: a red sandstone and conglomerate cemented by silica to form a hard, resistant layer that caps many of the exposed rocks and retards their erosion.

Wingate sandstone: the predominant stone in the monument. Fine-grained, light pink to buff-colored, not especially resistant to erosion; it tends to break off in huge vertical slabs that slump to the canyon floor.

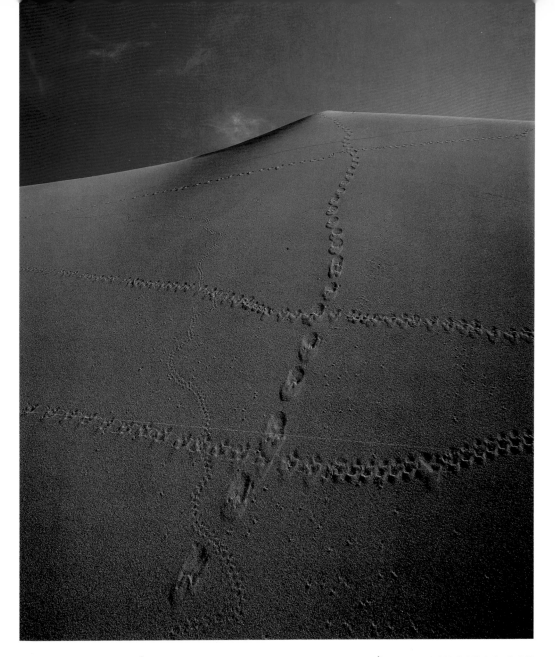

CAMEL CRICKET (ENDEMIC TO THESE SAND DUNES) AND KANGAROO RAT
TRACKS ON SAND DUNE, GREAT SAND DUNES NATIONAL MONUMENT

Chinle: a brick-red siltstone that sits directly on top of the ancient Precambrian Formation, one of the bedrocks of the planet.

These huge stony chunks of geologic time create odd spaces inside my head in which a giddy vapor like helium seems to drift and swirl. It's with relief that I bring my eye back to the smaller features playing about the ledges and walls.

A male collard lizard, in full breeding colors, scuttles over a rock with a sinuous wave of its whiplash tail.

Violet-green swallows, fragile, barely 5 inches long, weighing less than a pound, flit and play around Coke Ovens Overlook. They fly with the thrust of a bullet, their rapid wingbeats making a slurry buzzing sound.

Along Coke Ovens Trail I see a tiny butterfly, maybe $1^1/2$ inches wide, dancing over a stalk of yellow prince's plume. The black-and-gold marbled pattern on the back of its wings appears intricate and complex, a marvel of aesthetic design. But, like every adaptive feature, it no doubt serves a practical function as well. I follow it awhile, creeping as close as I can. Finally, as if tiring of the exercise, it spins away upslope.

Later, at the south end of the monument, I walk the trail to Devil's Kitchen, along a ridge overlooking a messy streambed. The stream flows out of a box canyon cluttered with rocks, shrubs, cactus and juniper trees.

The canyon isn't deep—20 to 30 feet. It's the confusion inside that attracts my attention, a messy tangle of plants and stones—as if someone shook the walls like a sock, knocking everything askew.

Attempting to impose order upon nature is pointless. "Traditionally," says John Briggs, author of *Fractals: The Patterns of Chaos*, "we have used Euclidian shapes—circles, squares, triangles—to model figures and landscapes … a process that tended to generalize and idealize the natural world."

Certainly it tended to cluster the more chaotic aspects into cuddly, generic patterns, making them seem more friendly and appealing. Nature is chaos, charged with danger and uncertainty. We need to understand that, to look for meaningful patterns in the midst of incessant replication, folded worlds within the tumult of similarly folded worlds.

The trail back to the car leads through a sandy arroyo carpeted with big sage. The silver-gray leaves ripple in the sluggish breeze. Heated by the midday sun, the plant gives off a musty odor. I pluck a few leaves and chafe them between my fingers. Immediately my nostrils fill with an aromatic scent. This is the heart of canyon country, raven country. To the east, up the long slope of the Rockies, lie other countries: Mountain/Bear, Alpine/Marmot, Plains/Buffalo. In all the world there are but four terrestrial biomes—desert, forest, tundra, grassland. Colorado has them all.

A dragonfly whirls through the air on multiple wings. Water icon, replenisher of thirst and hope. I crush more sage between my fingers. It's like a garden down in this steamy arroyo, fragrant and ambrosial. Time fractures into tiny splinters, each splinter, linked by elastic threads of organic consciousness, bearing new images, new feelings, new perceptions. The fecundity, the richness of it all, staggers me. When I die I want to be borne to my grave on a litter of sage.

SAND PATTERN,
GREAT SAND DUNES NATIONAL MONUMENT

Bibliography

Barker, Ted, Phil Leonard, and Bill McGlone. *Petroglyphs of Southeast Colorado and the Oklahoma Panhandle*. Kamas, Utah: Mithras, Inc., 1994.

Bird, Isabella. *A Lady's Life in the Rocky Mountains*. Norman: University of Oklahoma Press, 1960.

Bowles, Samuel. *The Parks and Mountains of Colorado: A Summer Vacation in the Switzerland of America, 1868*. Norman: University of Oklahoma Press, 1991.

Briggs, John. *Fractals: The Patterns of Chaos*. New York: Simon & Schuster, 1992.

Brown, Lauren, ed. *Grasslands*. New York: Alfred A. Knopf, 1989.

Ellis, Richard N., and Duane A. Smith. *Colorado: A History in Photographs*. Niwot: University Press of Colorado, 1991.

Emerick, John C. *Rocky Mountain National Park Natural History Handbook*. Niwot, Colo.: Roberts Rinehart Publishers, 1995.

Emerick, John C., and Cornelia Fleischer Mutel. *From Grassland to Glacier: The Natural History of Colorado and the Surrounding Region*. Boulder, Colo.: Johnson Printing, 1992.

Huber, Thomas P. *Colorado: The Place of Nature, the Nature of Place*. Niwot: University Press of Colorado, 1993.

Manning, Richard. *Grassland*. New York: Viking, 1995.

Marsh, Charles S. *People of the Shining Mountains: The Utes of Colorado*. Boulder, Colo.: Pruett Publishing Company, 1982.

Moore, Michael. *Medicinal Plants of the Mountain West*. Santa Fe: Museum of New Mexico Press, 1979.

———. *Medicinal Plants of the Desert and Canyon West*. Santa Fe: Museum of New Mexico Press, 1989.

Oppen, George. *Collected Poems*. New York: New Directions, 1975.

Pesman, M. Walter. *Meet the Natives: The Amateur's Field Guide to Rocky Mountain Flowers, Trees, and Shrubs*. Niwot, Colo.: Roberts Rinehart Publishers, 1992.

Pettit, Jan. *Utes: The Mountain People*. Boulder, Colo.: Johnson Printing, 1990.

Rinehart, Frederick R., ed. *Chronicles of Colorado*. Niwot, Colo.: Roberts Rinehart Publishers, 1993.

Ruxton, George Frederick. *Life in the Far West*. Norman: University of Oklahoma Press, 1951.

Sanders, Barry, and Paul Shepard. *The Sacred Paw: The Bear in Nature, Myth, and Literature*. New York: Viking, 1985.

Scott, Jim. *Pikes Peak Country*. Helena, Montana: Falcon Press, 1987.

Smith, Anne M., ed. *Ute Tales*. Salt Lake City: University of Utah Press, 1992.

Smithson, Michael T., and Bettie E. Willard. *Alpine Wildflowers of the Rocky Mountains*. Estes Park, Colo.: Rocky Mountain Nature Association, n.d.

Snyder, Gary. *Mountains and Rivers Without End*. Washington, D.C.: Counterpoint, 1996.

Sprague, Marshall. *Newport in the Rockies: The Life and Good Times of Colorado Springs*. Athens: Swallow Press/Ohio University Press, 1987.

Strickler, Dee. *Prairie Wildflowers*. Columbia Falls, Mont.: The Flower Press, 1986.

Trimble, Donald E. *The Geologic Story of the Great Plains*. Medora, N. Dak.: Theodore Roosevelt Nature and History Association, 1990.

Trimble, Stephen. *Rim of Time: The Canyons of Colorado National Monument*. Fruita, Colo.: Colorado National Monument Association, 1993.

Waters, Frank. *Midas of the Rockies: The Story of Stratton and Cripple Creek*. Athens: Swallow Press/Ohio University Press, 1989.

Photo-Technical Information

The majority of these images were photographed with a Toyo 45AR 4x5 field camera, with a few photographed with a Nikon F3HP (35mm) and a Pentax 6x7. The primary film used was Fuji Velvia. An 81A filter was used in some instances to warm up the blue cast on cloudy days.

Good close-up photography (and all other types of photography) requires good light. The best light for most close-up and mid-range situations is the soft light of an overcast day, although in certain circumstances early morning or late afternoon light may be appropriate (this type of light is usually better for photographing larger vistas). Occasionally, when the sun was out with no hope of clouds to soften the light, I used a diffuser in the form of a conical "tent" or a translucent foldable disc. Open shade can also provide soft light but beware of the blue cast that comes with it, especially where clear blue skies are present (as in Colorado). Perhaps the most troublesome "technical" problem landscape photographers face is wind. In a couple of instances while photographing for this book, I used my diffuser tent to lessen its effect on moving flowers. (I remember one time in the grasslands with Conger hanging on to the diffuser for dear life while I tried to find that one moment of stillness.) But for the most part it just takes patience, and with the beauty of Colorado all around in every direction, patience is inevitably rewarded.

J.C. LEACOCK

About the Authors

PHOTO BY FREDERICA GEORGIA

J.C. LEACOCK is an outstanding photographer whose work has appeared in many books, calendars and magazines, including *Sierra*, *Outside*, *Wilderness* and *Audubon*. Most recently, his work has been included in *Echoes from the Summit*. J.C. lives with his wife in Nederland, Colorado.

CONGER BEASLEY JR. is an award-winning nature writer whose latest book, *We Are a People of This World: The Lakota Sioux and the Massacre at Wounded Knee*, was given the Western Writers of America Spur Award for the best contemporary nonfiction book published in 1995.

JULIE N. LONG is an award-winning designer whose fine touch graces many books. She lives with her husband and her daughter in Breckenridge, Colorado.